San Pedro Bay

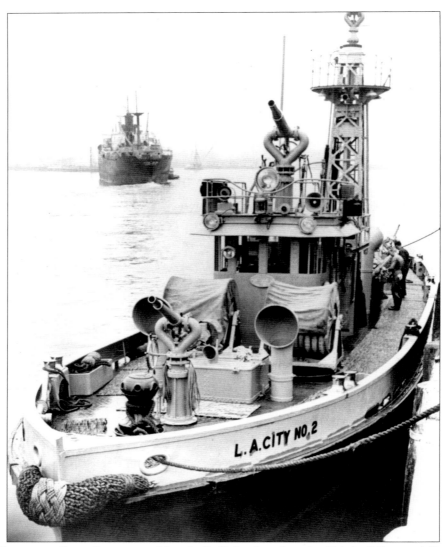

Los Angeles City Fireboat No. 2. Built by Los Angeles Shipbuilding and Drydock Corporation (Todd Shipyard) in San Pedro at a cost of $214,000, this vessel was commissioned in December 2, 1925, and went into service 25 days later with a crew of 14. It battled its first major fire on March 3, 1926, when the fully loaded schooner *Sierra* burned at the E. K. Wood Lumber Company wharf. In 1965, Fireboat No. 2 was renamed the *Ralph J. Scott,* and in 1976, the boat was pronounced a Los Angeles City Historical Cultural Monument. Listed on the National Register of Historic Places, No. 89001430, and designated a National Historic Landmark on June 30, 1989, it was finally retired in 2003 after 79 years of service.

On the Cover: This *c.* 1944 postcard shows the inner side of Cabrillo Beach, seen from Government Breakwater. A sign in the distance advertises "Seaplane Rides," and many beach umbrellas dot the sand. Buildings and houses of Fort MacArthur, Lower Reservation sit on the hill in the background.

POSTCARD HISTORY SERIES

San Pedro Bay

Joe McKinzie

Published by Arcadia Publishing
Charleston SC, Chicago IL, Portsmouth NH, San Francisco CA

Printed in Great Britain

Library of Congress Catalog Card Number: 2005929117

For all general information contact Arcadia Publishing at:
Telephone 843-853-2070
Fax 843-853-0044
E-mail sales@arcadiapublishing.com
For customer service and orders:
Toll-Free 1-888-313-2665

Visit us on the Internet at www.arcadiapublishing.com

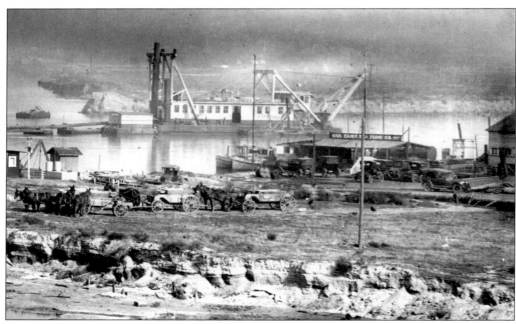

EARLY HARBOR DEVELOPMENT, 1910s. The work of dredging and widening the main channel is being done by the Los Angeles Dredging Company in this image. The size of the Van Camp Sea Food Company building reveals the humble beginnings of the fledgling fishing industries in San Pedro Bay. Over the past century, the harbor went through many changes. It remains under constant redevelopment.

CONTENTS

ACKNOWLEDGMENTS

I need to thank my wife, Martha (a schoolteacher), for correcting my spelling in this book. My primary sources for confirming most of the information that I was able to obtain from the photo postcards were the San Pedro Bay Historical Society's books *San Pedro: A Pictorial History Updated through 1990* and *The Vincent Thomas Bridge: San Pedro's Golden Gate*, as well as *Battleship Country* by Harvey M. Beigel.

INTRODUCTION

The images used in this book are from what is referred to by postcard collectors as "real photo cards"—actual photographs with postcard backs ready for mailing, unlike other lithographed cards where the image is printed on the card.

By an act of Congress on May 19, 1898, private printers were granted permission to print and sell cards that bore the inscription "Private Mailing Card." Messages were not allowed on the back of the card, so a small space was left on the front for notes from the sender. On December 24, 1901, the government granted the use of the phrase "Post Card" (or the word "Postcard") to private printers. On March 1, 1907, a major change was made to the backs. The left side of the back of the card was left blank for messages, while the right side was for the address.

The popularity of lithographed postcards caught Eastman-Kodak's attention, and they issued an affordable "Folding Pocket Kodak" camera around 1906. This allowed the masses to take black-and-white photographs and have them printed directly onto paper with postcard backs. These cameras shared two unique features: their negatives were postcard size (making for clear images), and they had a small, thin door on the rear of their bodies that, when lifted, enabled the photographer to write an identifying caption or comment on the negative itself. Some of the images of real photo postcards were mass-produced to sell to the public. There were also some cards of which only one copy was ever made, making them a rare, document of our past. Some of the real photo postcards in this book will look familiar to many people, but some are one-of-a-kind.

Juan Rodriguez Cabrillo was the first of the European explorers to land in San Pedro Bay on October 8, 1542. He named the area Bahia de Los Fumos (Bay of Smokes). A few years later, in 1602, Sebastian Vizcaino landed in the bay and changed the name of the area to San Pedro.

Trade was not a new occurence in the San Pedro Bay. Since the early Spanish Mission days, the sleepy bay did more than its share of cargo loading and unloading. After the statehood of California was finalized, the Land Act of 1850 and immigration brought changes to the bay.

One of the businessmen to arrive was a German immigrant, Augustus W. Timms, who quickly brought the bay frontage land of Sepulveda Landing from Juan and Jose in 1852. Timms improved the wharf area by building warehouses, a corral, hotel, and a store. This modest complex intended for passengers in transit became popular with summer vacationers from Los Angeles. The area that became known as Timms Landing would have been located at the base of Fisherman's Slip today. In 1888, Timms deeded three acres of land to the township of San Pedro to be a cemetery known as Harbor View Memorial Park.

Phineas Banning, known as the Father of the Harbor, settled in the Wilmington area in the 1850s. He was the driving force to develop the San Pedro Bay area. In 1858, he founded the town of Wilmington and was instrumental in bringing the railroad, telegraph, and the U.S. Army to the community. His years of work and petitioning of Congress ultimately resulted in the funding of the Point Fermin Lighthouse in 1874 and Government Breakwater, completed in 1912. The harbor area has been under continuous construction and redevelopment ever since then and will continue to change in the years to come.

One

Point Fermin,
Breakwater, Bathhouse,
and Deadman's Island

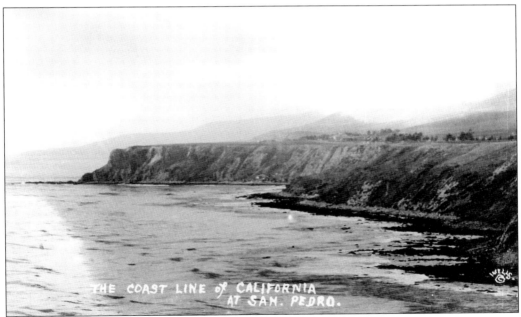

COASTLINE OF CALIFORNIA AT SAN PEDRO. This *c.* 1920 view, looking west from Point Fermin to a cluster of houses on the bluff, forms the Japanese colony of the White Point dry farmers who farmed the hillside. They also fished for the variety of seafoods that were abundant in the waters adjacent to Point Fermin, White Point, and Portuguese Bend. (Courtesy of IVELLS.)

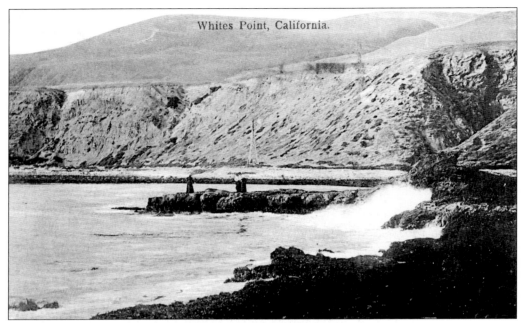

WHITES POINT. This postcard was mailed on October 12, 1906, to Pasadena with the message, "This is our address P.O. Box 2349 San Pedro." Hopefully the person receiving this postcard knew who sent it. This is what White Point looked like before any houses or building were built along the coast or hillside of Palos Verdes. Three people stand on the rocks by the ocean while a lone windmill spins in the background.

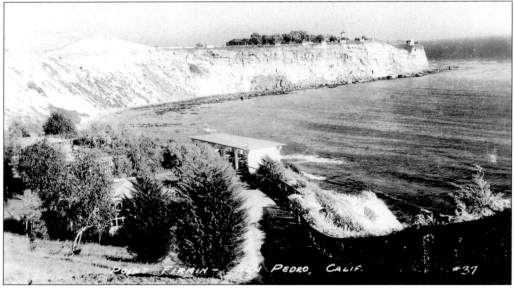

POINT FIRMIN. This *c.* 1930s view looks east toward Point Fermin's main park from Wilder's Addition, which was named for one of San Pedro's early developers. In the background is the Point Fermin Lighthouse, which prominently sits on the headland, surrounded by trees in the park. In the foreground is just one of the many roofed lookouts where people could picnic or just sit and enjoy the ocean view.

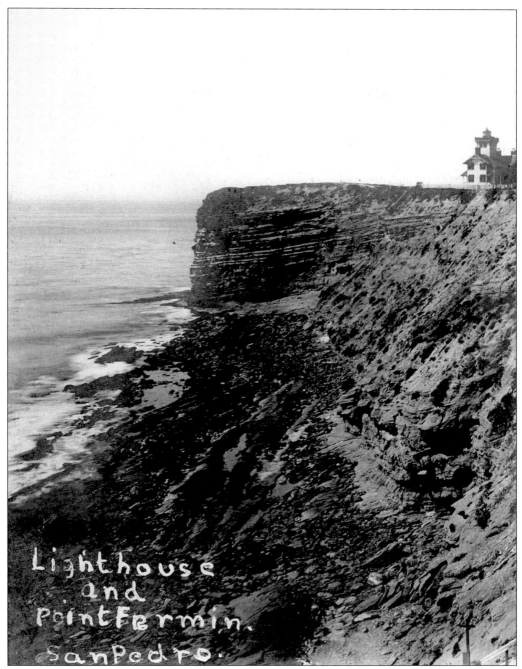

Lighthouse
and
Point Fermin.
San Pedro.

LIGHTHOUSE AND POINT FERMIN. This postcard, mailed on March 30, 1909, shows a great view of the 100-foot cliffs of Point Fermin and the lighthouse. Jose Diego Sepulveda "donated" the land for the lighthouse, since the $35 check from the U.S. government was never cashed. To this day, the check remains in Washington, D.C. The Victorian structure was built in 1874 with lumber shipped from Northern California. The Fresnel lens used to light this lighthouse was brought around Cape Horn by sailing ships from France.

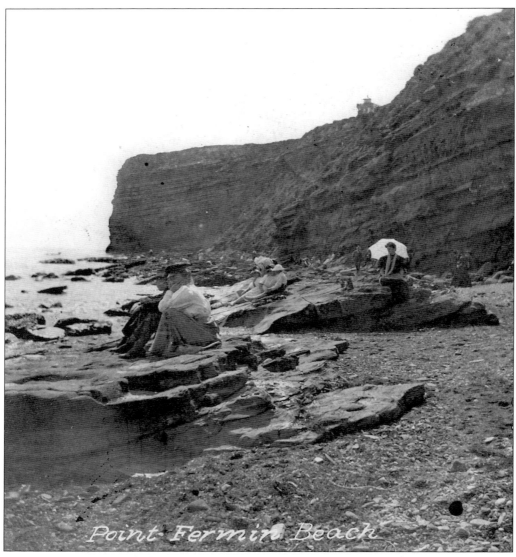

Point Fermin Beach

POINT FERMIN BEACH. This postcard was mailed April 20, 1908, "Easter Sunday on the rocks 1908." People are sitting on the rocks below the Point Fermin cliff, with just the top of the lighthouse visible. The first and last lighthouse-keepers at Point Fermin were women. Mary and Helen Smith kept the light from December 15, 1874, until 1882. Mary is listed as the official keeper. Thelma and Juanita Austin assumed their father's position as keeper in 1925, after both of their parents had passed away. Thelma stayed until 1927, when the Los Angeles City Recreation and Parks Department assumed care of the station and opened the grounds for use as a park. The lighthouse was automated and powered by electricity, making a keeper no longer necessary.

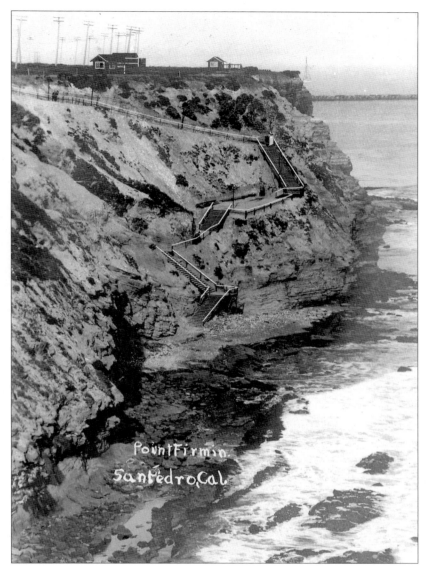

POINT FIRMIN. This postcard was mailed on March 30, 1909, and shows a view of the winding stairway from the top of Point Fermin down to the rocky beach area (no bathhouse is at base of stairs yet). The telephone poles, buildings, and stairs are no longer there, and the area is now known as "Sunken City."

FERMIN OR FIRMIN? In categorizing and collecting these photo postcards, I was perplexed and confused by the two different spellings of the name of Spanish missionary priest Padre Francisco Fermin de Lasuén. British explorer George Vancouver is credited for naming Point Fermin after this friend of his who had completed Father Serra's task of establishing the 21 missions of California. After a little investigation, I confirmed that neither is right or wrong; rather, it depends on what language one is using. "Fermin" is the Spanish spelling of the name and has been the spelling preferred since the 1920s. Most of the earlier cards use "Firmin," the English form of the same name.

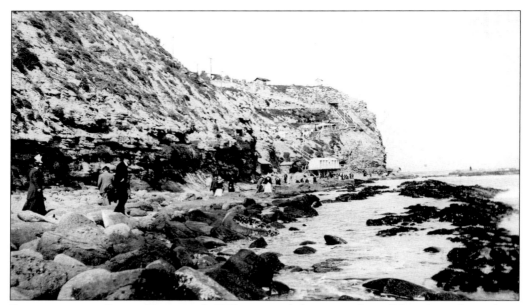

BATHHOUSE AT POINT FERMIN. A 1910s postcard shows people walking along the rocks at the base of Point Fermin after descending the wooden stairs. The bathhouse and stairways are no longer here. In 1929. a large part of the cliff started began to shift slightly, but that did not keep people from living there. By the 1940s, there had been extensive land movement and most of the buildings were relocated.

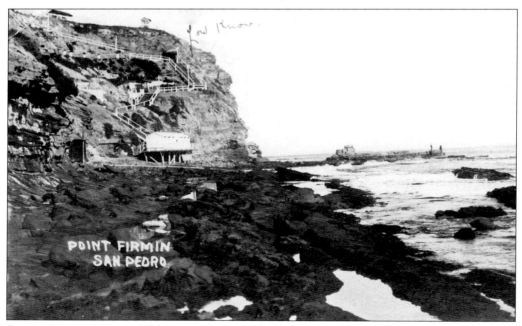

POINT FIRMIN BEACH. This postcard was mailed on June 30, 1916, with this message: "Had a visit to the point. Pleasant day but a little on the cool side. Will write a letter tomorrow." The photograph offers a good close-up of the stairs.

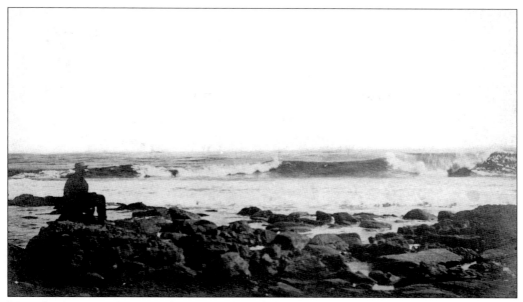

MAN SITTING ON ROCKS. This postcard, mailed on January 13, 1911, shows a man sitting on the rock next to the ocean at Point Fermin. In trying to be succinct in verbiage, the message is a bit confusing but reads, "Dear Sister and all. Our walking effort to get home. Think will be able to start about Mo. Mess from Mom. will write letter this week. Love to all, Jallir."

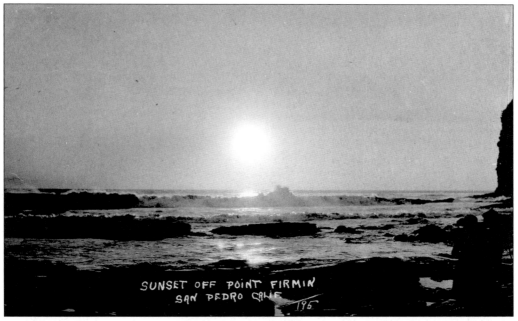

SUNSET OFF POINT FIRMIN. This 1920s postcard shows a wonderful sunset, with the waves breaking over the rocks at Point Fermin. This postcard did not have an address but did have an interesting message: "Bro Charles. This is the way they come at you out here. I mean the waves. Scott."

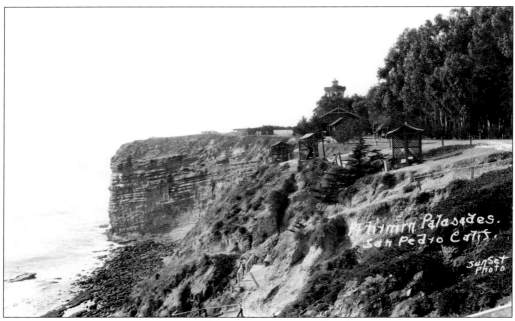

POINT FIRMIN LIGHTHOUSE PALASADES [*SIC*]. This *c.* 1920s postcard shows the Point Firmin Lighthouse poking out above the trees. The area around the lighthouse was developed into a park, as it remains today. However, only remnants of the stairs and the path the leading to the ocean are visible today. (Courtesy Sunset Photo.)

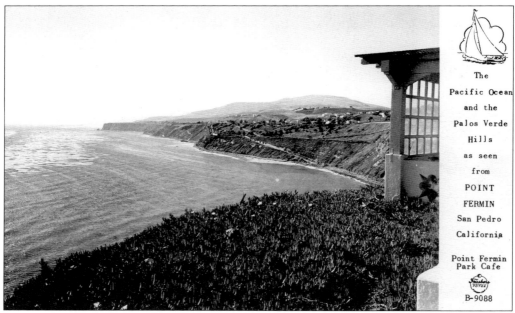

POINT FERMIN VIEW. The Wilder Addition of Point Fermin can be seen in the distance of this 1940s postcard, with a pagoda of Point Fermin Park in the right foreground. (Courtesy of Frasher Fotos, B-9088.)

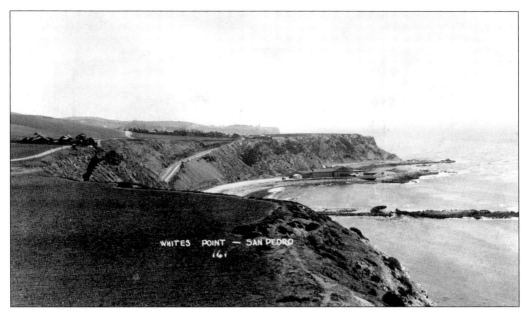

WHITE POINT HOT SPRINGS. This 1920s view shows the White Point Hotel with its two restaurants. This once famous seaside resort featured a sulphur spring bathhouse and an Olympic-size, salt-water plunge. The house on the left is part of the Japanese community that farmed the hillside area for many years. Throughout the years, there has always been confusion over the name: "White Point" or "White's Point." While the official name is White Point, the confusion will, most likely, continue.

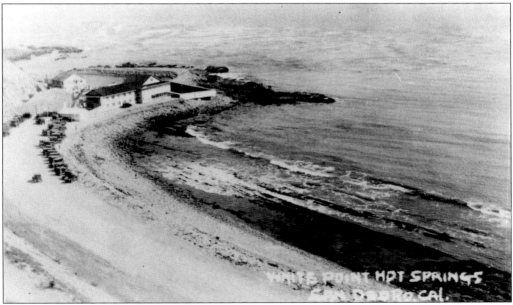

WHITE POINT SPA. This *c.* 1925 view shows the White Point Spa facilities and parking lot, which was started in 1917 by enterprising Japanese businessman Tamiji Tagami in association with Don Roman Sepulveda. Both these men were instrumental in the construction of this area, but Sepulveda held title to the land that was part of the Rancho de Los Palos Verdes.

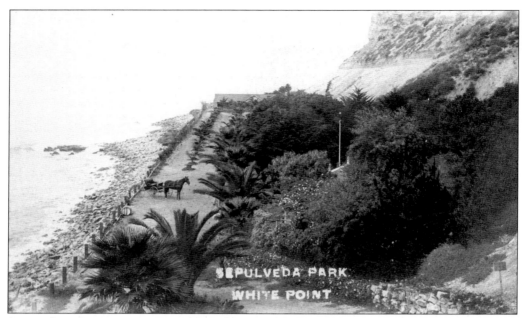

SEPULVEDA PARK, WHITE POINT. Unfortunately, this great 1920s view of Sepulveda Park at White Point only shows very little of the building. The prestigious area's fountain and some of the terrazzo dance floor remain here today, as well as a few of the original royal palm trees. This spot is now part of Royal Palms State Park.

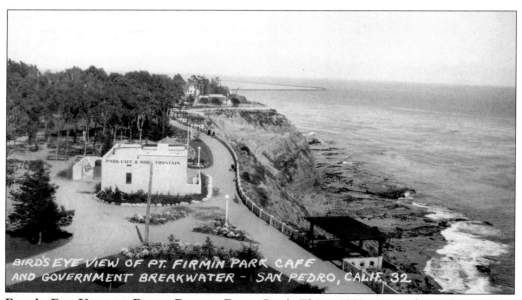

BIRD'S-EYE VIEW OF POINT FERMIN PARK CAFÉ. This *c.* 1930 picture shows the coastline looking east, as seen from the top of the lighthouse tower. The Park Cafe building is now home to the American Cetacean Society, a nonprofit organization founded in 1967 to protect whales, dolphins, porpoises, and their habitats. These animals all belong to the scientific order Cetacea. The other buildings in the distance have been demolished or moved out of the area due to land movement.

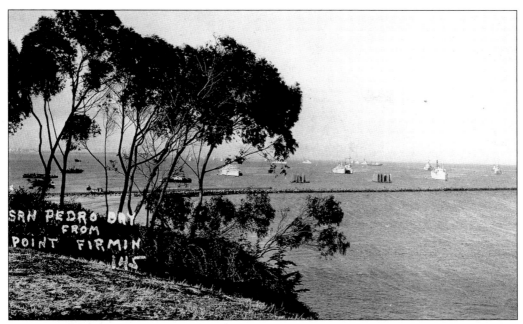

VIEW OF BREAKWATER FROM POINT FERMIN PARK. This 1930s postcard carried the following message: "This view is from Point Firmin Park lovely spot in a residential district. Looking down one can see the huge waves dashing against the rocks. I love the sight–sound–smell and feel of the ocean but not the taste."

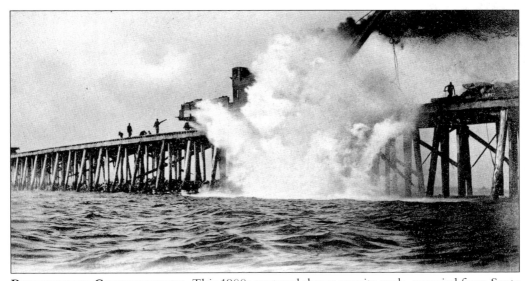

BREAKWATER CONSTRUCTION. This 1900s postcard shows granite rock, quarried from Santa Catalina Island, being dumped from rail cars on the wooden trestle to form the 190-foot wide base of the breakwater.

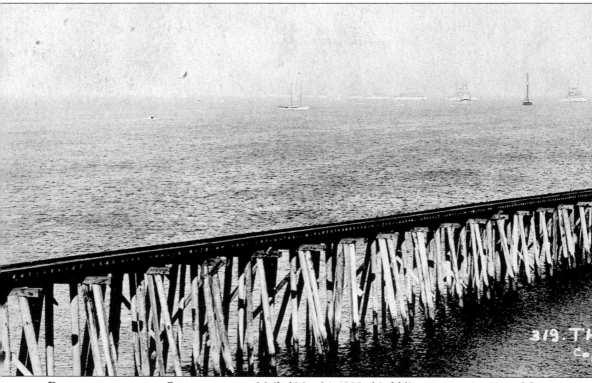

BREAKWATER UNDER CONSTRUCTION. Mailed May 26, 1908, this folding panoramic postcard shows the Great White fleet anchored at San Pedro. Sixteen battleships visited the harbor during a round-the-world goodwill cruise initiated by Pres. Theodore Roosevelt on April 18, 1908. Between 1899 and 1912, a total of three million tons of rock were dumped from railway flat cars to build the breakwater. In this image, the squared granite cap rocks for the breakwater have not yet been placed. The seaside caps weighed eight tons each, and the harbor side caps weighed three tons each. (Courtesy of Lester Clement Barton.)

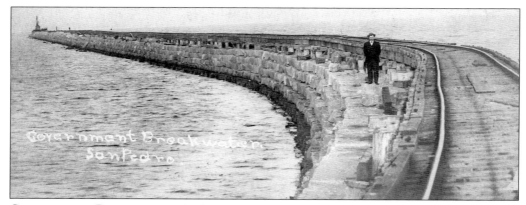

GOVERNMENT BREAKWATER. A 1910s postcard shows a lone man standing on the inside of the breakwater, next to the rail lines that were used to haul the rock to be dumped from the trestle. The top of the breakwater is 20 feet wide and 14 feet above the low tide line.

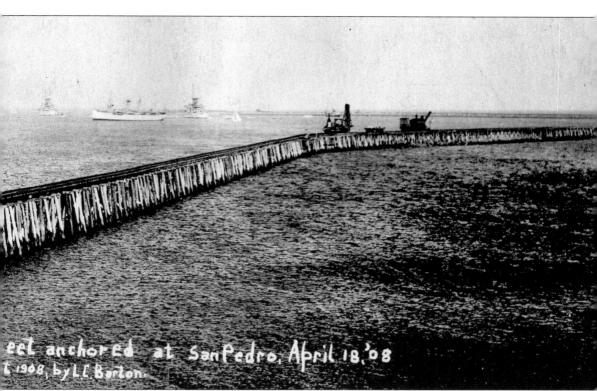

eet anchored at San Pedro, April 18, '08
t 1908, by L. E. Burton.

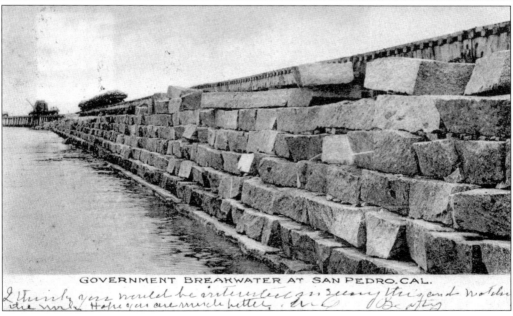

GOVERNMENT BREAKWATER AT SAN PEDRO, CAL.

GOVERNMENT BREAKWATER. Mailed August 12, 1910, this postcard's message reads, "You would be interested in seeing this card watching the work. Hope you are much better." This angle really shows the massive size of the neatly placed rocks and rail flatcars of rock on top of the breakwater.

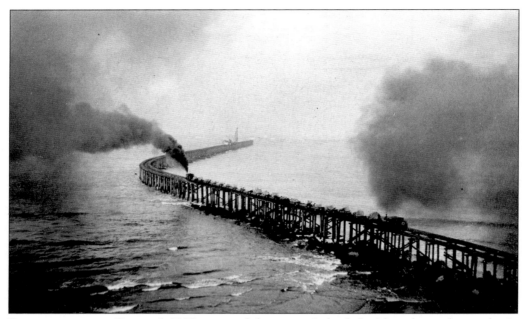

BRINGING IN THE ROCK. A 1900s postcard shows a train loaded with rocks on the trestle. At a desired location on the proposed sea wall, the rocks would be dumped to form the base for the breakwater.

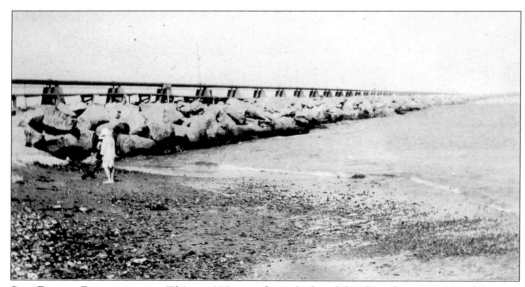

SAN PEDRO BREAKWATER. This c. 1915 view from the beach level on the oceanside of the new breakwater shows a woman walking along the shoreline. This area became the site of Cabrillo Beach, which was developed on both sides of the breakwater.

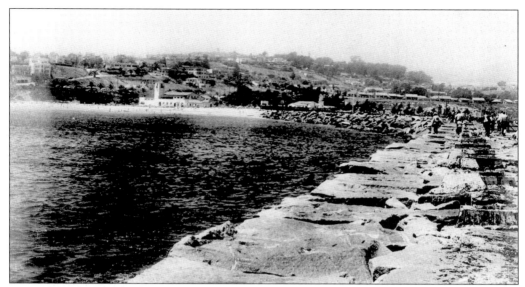

ON TOP OF THE GOVERNMENT BREAKWATER. A mid-1930s postcard finds people walking along the topside of the Government Breakwater. This view looks back toward Cabrillo Beach and Bathhouse. The rail lines used by the trains to haul the rock for building the breakwater have been removed.

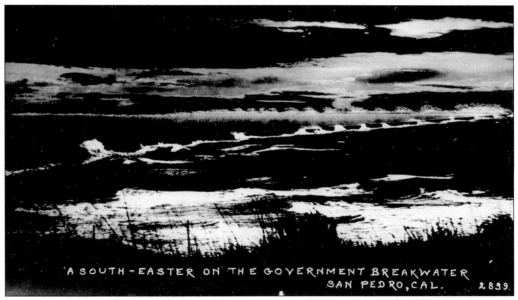

'A SOUTH-EASTER ON THE GOVERNMENT BREAKWATER
SAN PEDRO, CAL. 2839.

A SOUTHEASTER ON THE GOVERNMENT BREAKWATER. This 1939 postcard captures a moonlit view of waves crashing over the breakwater of the Los Angeles Harbor. These "South-Easterlies" were one of the main reasons this breakwater was placed here. Early vessels to the harbor always feared the advent of the "south-easterly" storms, since the geographical layout of the early harbor lent little, if any, protection from the southeastern storms. Before the construction of the breakwater, many ships had to ride out those storms on the sea between Point Fermin and Catalina Island. The little natural protection that the harbor had was a reason other locations were investigated during decision-making of where to locate the Los Angeles Harbor.

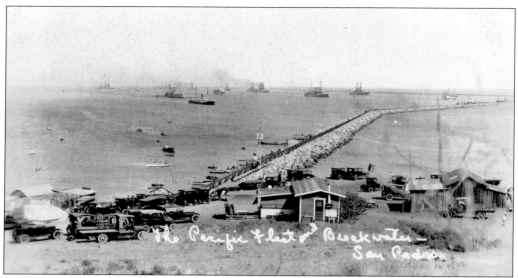

PACIFIC FLEET AND BREAKWATER. This 1920s postcard shows the Pacific fleet safely anchored behind the government breakwater. The building in the center is the Angler's Inn, located where Cabrillo Beach, Café, Bathhouse, and picnic area were later developed.

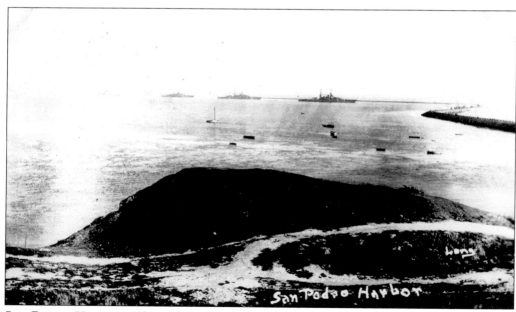

SAN PEDRO HARBOR. This early 1920s postcard shows the battleships anchored inside the new breakwater to the right. The foreground, here, shows mudflats that would later become inner Cabrillo Beach, Boathouse, dock, and parking lot.

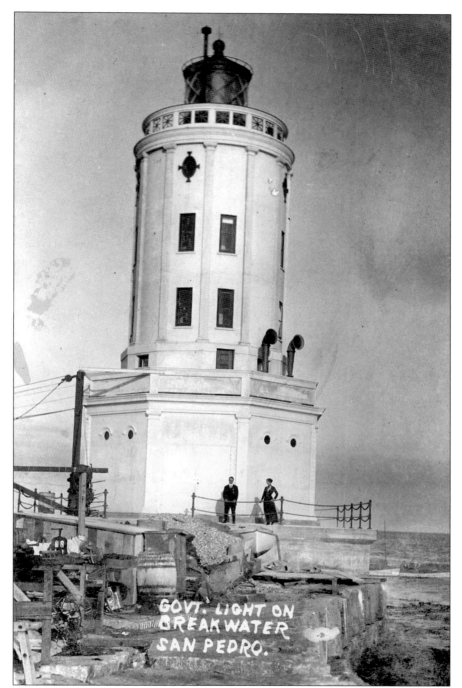

ANGELES GATE LIGHTHOUSE. This postcard was mailed November 13, 1913, with the following message: "Hello how are you getting along now fine I hope. I haven't hear [sic] from you for so long it seems like an age. Take a look at me and see if I look natural. A friend and I went out there on 2nd of November taking out lunch and had a delightful time and had our picture taken standing at the base. WOW."

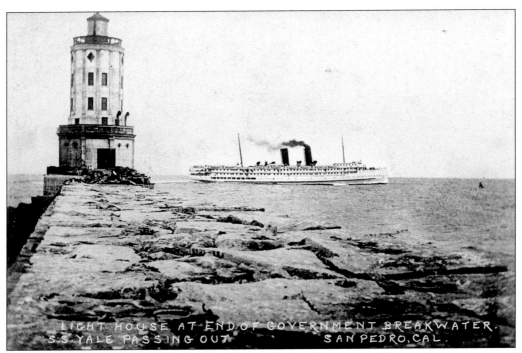

LIGHTHOUSE AT ONE YEAR. The one-year-old Angel's Gate Lighthouse sits at the end of the Government Breakwater. The SS *Yale* sails out of the harbor on one of its many trips. This postcard is postmarked May 29, 1914.

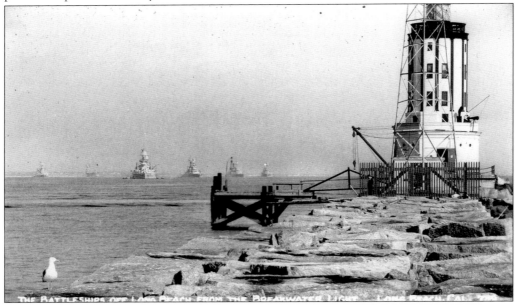

ANGEL'S GATE LIGHTHOUSE WITH U.S. BATTLESHIPS. This *c.* 1935 view shows the Pacific fleet of U.S. battleships anchored in the outer harbor, with the lighthouse in the foreground. The lighthouse tower was hit by a Navy battleship and just missed being knocked off its foundation. For years, the incident was labeled confidential in the Navy files.

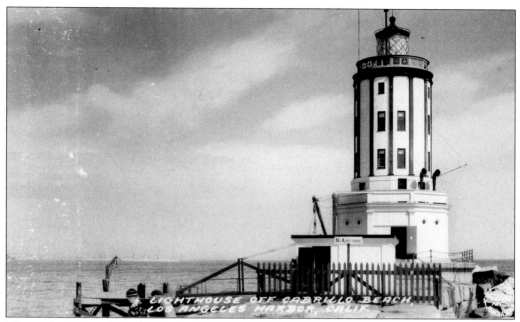

MAJESTIC ANGELES GATE LIGHTHOUSE. Built in 1913 on a 40-foot concrete square, the lighthouse's octagon base framework is of structural steel, with steel plates to the top of a 10-sided second floor. The cylindrical top three stories are made with 12 columns, white (cement) and black.

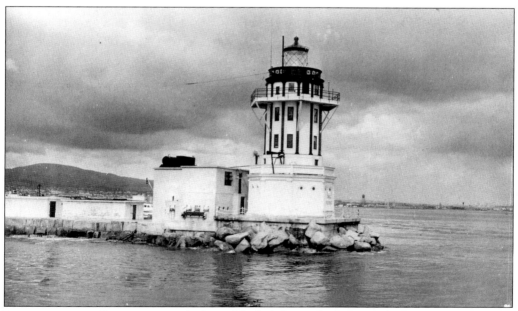

LIGHTHOUSE ON BREAKWATER. A view of the lighthouse, looking north, shows a widow's walk around the upper floor of the structure. This structure survived the 1933 Long Beach earthquake as well as the 1939 hurricane that caused the tower to lean slightly toward shore. This is the only lighthouse on the West Coast that has a green flashing light instead of the normal white light.

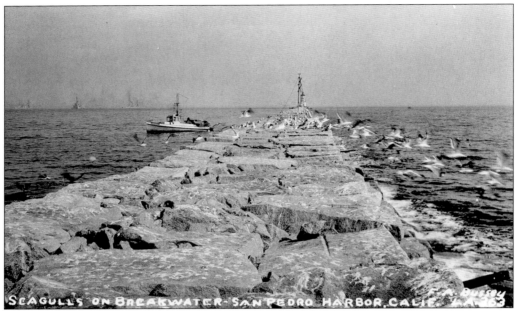

SEAGULLS ON BREAKWATER. In this *c.* 1920s postcard, seagulls cross over the breakwater hoping to scavenge some of the scraps of the catch of a fishing boat coming to port. Locals affectionately knew the original, deep-throated, two-tone horn at this lighthouse as "Moaning Maggie." It was replaced by a higher-pitched, single-tone horn nicknamed "Blatting Betty." (Courtesy of F. A. Bussey.)

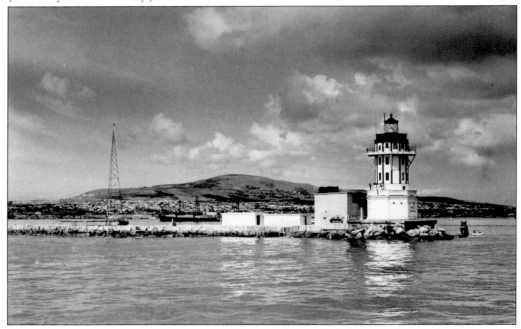

ANGELES GATE LIGHTHOUSE. This 1950s postcard shows the lighthouse that marks the entrance to Los Angeles Harbor and was automated in 1973 (thus eliminating a need for a keeper) powered by solar batteries. Note how undeveloped Palos Verdes Hill is.

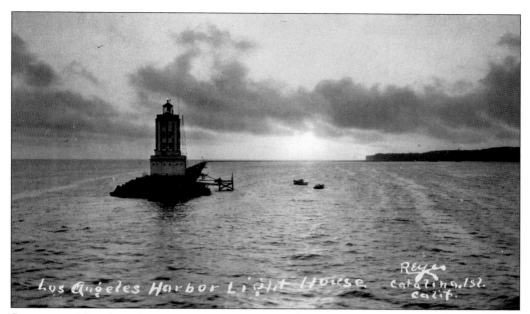

SUNSET AT HISTORIC BREAKWATER AND LIGHTHOUSE. This 1930s view of the historic Los Angeles Harbor lighthouse, better known as Angel's Gate Lighthouse, has marked the entrance to the Port of Los Angeles since 1913. Its Romanesque tower distinguishes it from any other lighthouse in California. (Courtesy of Reyes Catalina Island.)

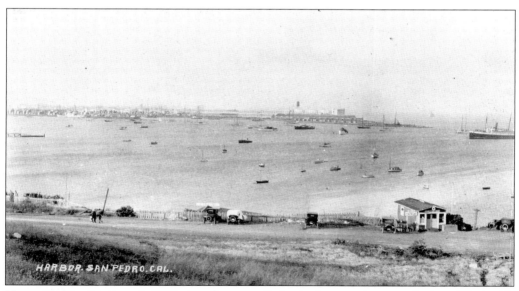

HARBOR SAN PEDRO. A 1927 view from San Pedro looks over the outer harbor, filled with numerous small boats and pleasure craft. In the foreground is a small building, the Anglers Inn, that also sold bait and tackle. In the distance are Warehouse No. 1 and other Los Angeles warehouse storage buildings.

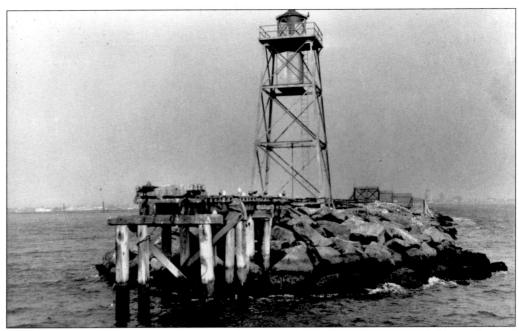

QUEEN'S GATE LIGHTHOUSE. This is a 1950s view of the Queen's Gate Lighthouse, located on the east end of Middle San Pedro Breakwater. Completed in 1949, it is unusual in that its structure is a departure from the classic lighthouse architecture. Its rectangular base is stationed on six columnar legs resembling a robot from a 1950s science fiction movie; hence the name "robot light."

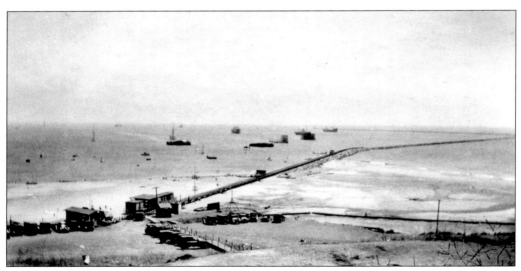

CABRILLO BEACH AND BREAKWATER. This 1920s photograph was taken before the boat or beach house were constructed. The inner and outer beaches that make up Cabrillo Beach are starting to take shape. Within the next decade, the Anglers Inn and other small buildings will be replaced by the new bathhouse and paved parking lot.

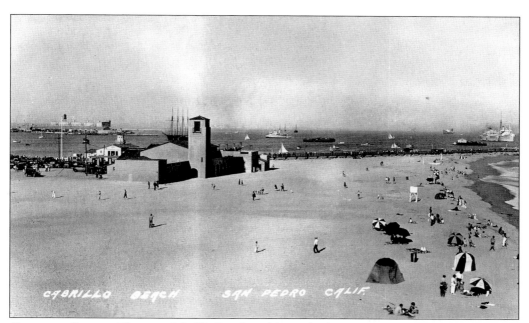

CABRILLO BEACH. The new Cabrillo Beach Bathhouse built in 1932 was a Mediterranean–style structure of 26,000 square feet. It was the last of the bathhouses built in southern California.

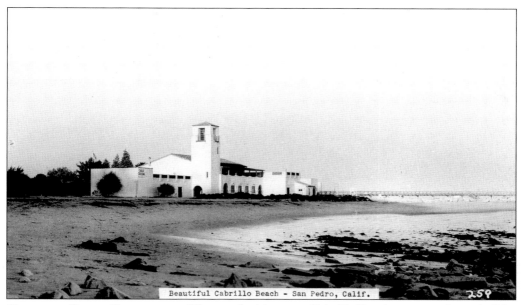

Beautiful Cabrillo Beach - San Pedro, Calif.

CABRILLO BEACH BATHHOUSE. The new bathhouse at Cabrillo Beach was near the end of the the Red Car (streetcar) line running from Los Angeles to San Pedro and out to Point Fermin. A visitor to the bathhouse could pick up a swimsuit and a towel for a 10¢ rental fee and enjoy a day at the seashore.

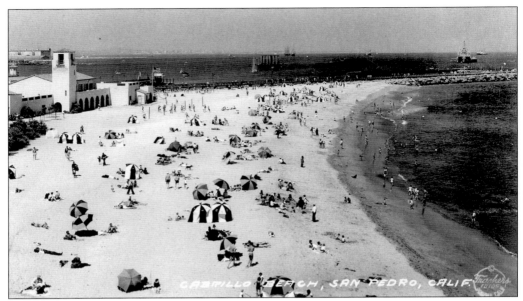

OCEAN SIDE OF CABRILLO BEACH. This *c.* 1940 view from the cliffs above Cabrillo Beach looks east, with the beach filled with sunbathers on the sand. The bathhouse also had a café where beachgoers could grab a bite and a drink. (Courtesy of Frasher Fotos.)

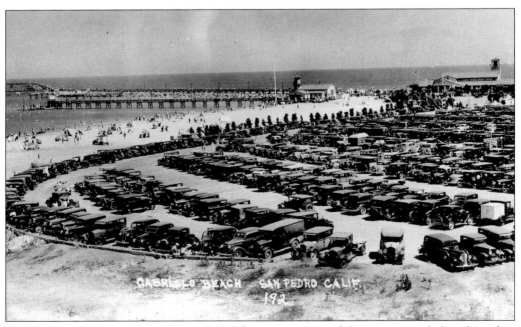

CABRILLO BEACH. This 1930s postcard features a view of the very crowded parking lot, as seen from the cliffs above, with the pier, breakwater, beach house, and boathouses in the background.

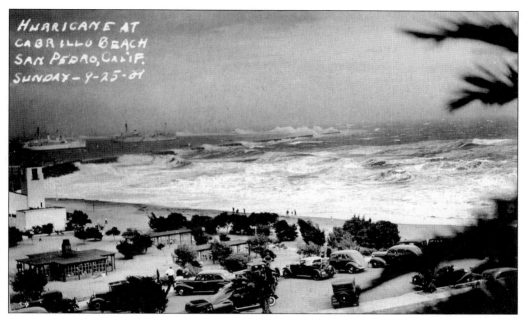

HURRICANE AT CABRILLO BEACH. This view from the cliffside shows the wind and waves hitting onshore at the outer beach on Sunday, September 25, 1939. The parking lot is full of cars, and people are out walking out on the beach during the storm. In the distance, ships are inside the breakwater, which is somewhat visible with the waves crashing over it.

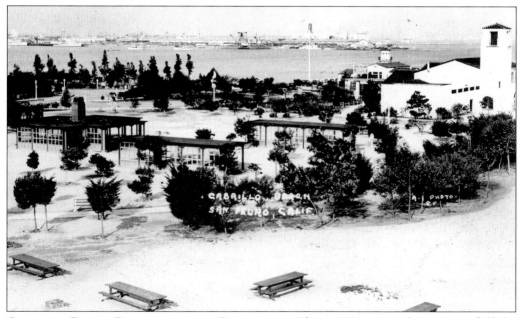

CABRILLO BEACH BATHHOUSE AND BOATHOUSE. This *c.* 1940 postcard is a view of all the picnic tables and covered patio areas among the trees in front of the bathhouse and boathouse. Across the harbor, Warehouse No. 1 and other storage buildings can be seen in the distant background. (Photograph by A-1 Photo.)

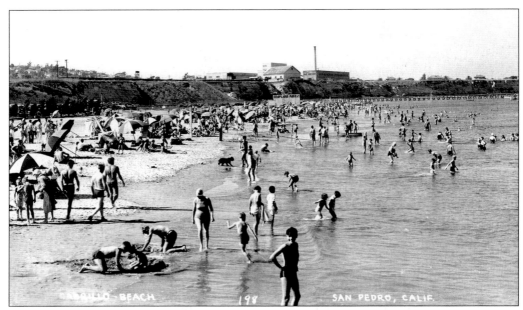

BATHERS ENJOYING THE BEACH. This *c.* 1944 postcard shows the view of the inner side of Cabrillo Beach from the government breakwater. A sign in the far distance advertises "Seaplane Rides" while many beach umbrellas dot the sand. Buildings and houses of Fort MacArthur, Lower Reservation sit on the hill in the background.

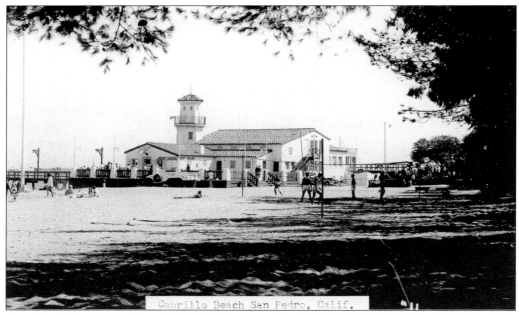

BOATHOUSE. This *c.* 1945 postcard shows volleyball players and sunbathers enjoying the beach next to the boathouse, located inside the breakwater at Cabrillo Beach. This building and the bathhouse were used during the 1932 Summer Olympic Games for boating events.

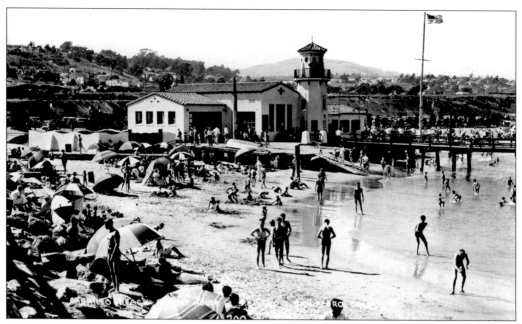

CABRILLO BEACH AND BOATHOUSE. This postcard, mailed August 10, 1944, posed a short question as its message: "Part of our fair city?" The great view features the boathouse, which housed the first office for Pan Am Airlines. Pan Am flew Clipper seaplanes from the waters of San Pedro Bay on international flights to the Orient and New Zealand.

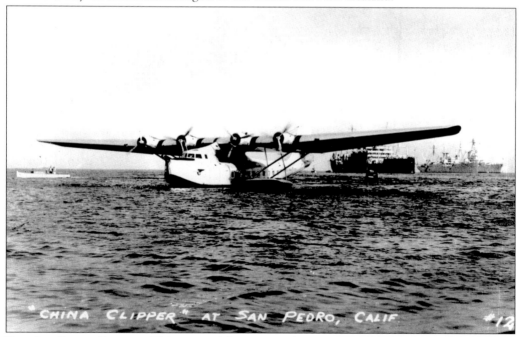

PAN AM CHINA CLIPPER. This postcard from November 19, 1935, shows one of Pan Am's flying boats in San Pedro Bay. They used the outer harbor area as a runway for takeoffs and landings. The flights were discontinued because of the outbreak of World War II.

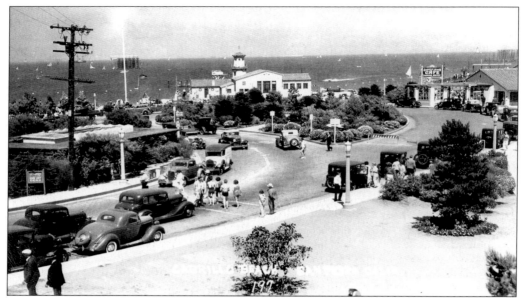

CABRILLO BEACH. This postcard was mailed January 30, 1950, with the message, "We r as usual only Novelene is up today for first time since week ago last night. They say she had internal measles (didn't break out) did you ever hear of such? When you visit this summer we'll spend a day at this beach." What a wonderful day at the beach this must have been when this picture was taken.

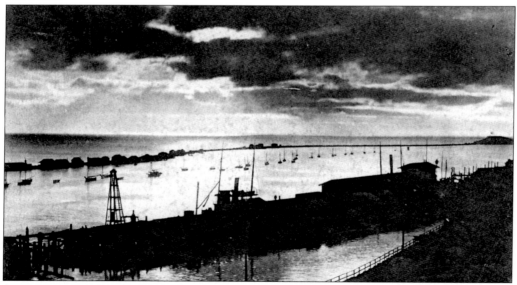

SUNRISE OVER THE 200-FOOT STONE JETTY AND DEADMAN'S ISLAND. This postcard, mailed on March 15, 1906, really shows that Deadman's Island was connected to Rattlesnake Island (later called Terminal island) by a 2,000-foot-long stone jetty that was built between 1871 and 1880. Silt was deposited on the outside of this new breakwater, and the channel was deepened to allow shallow draft steamers and schooners to enter the inner harbor and tie up directly to the docks. Before this, people and cargo from ships anchored in the outer harbor were taxied to the docks in smaller boats.

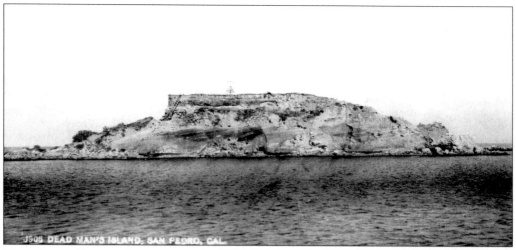

DEADMAN'S ISLAND LANDMARK. In 1927, the removal of Deadman's Island was slated. The island had become a hazard to navigation, and plans were put in place to widen the main channel. The project was completed in 1929, and the material from it was used as fill to create Reservation Point, part of Terminal Island. This island's destruction meant that the landmark that identified the harbor since its discovery had now disappeared.

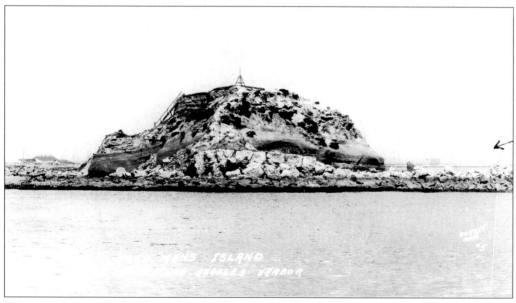

DEADMAN'S ISLAND. During the Battle of Dominguez Ranch in October 1846, several Americans were killed and buried on a small Island in the harbor of San Pedro, just south of Rattlesnake Island (now Terminal Island). Pictured in the 1900s, the island became known as "Dead Man's Island.. (Photograph by Sunset, San Pedro.)

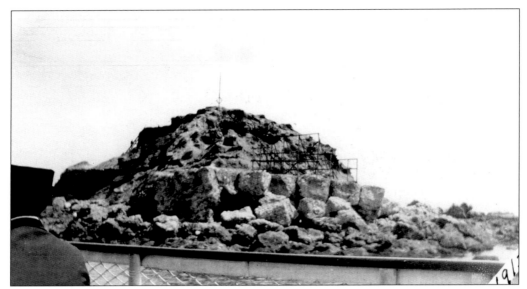

DEADMAN'S ISLAND, CLOSE-UP. This postcard has a handwritten caption: "May 15, 1913 Dead Man's Island San Pedro Cal." The framework for a new advertising billboard being erected on the island is visible. This rocky promontory rises out of the water nearly 50 feet and two-and-a-half acres at its base, near where Reservation Point is today on Terminal Island.

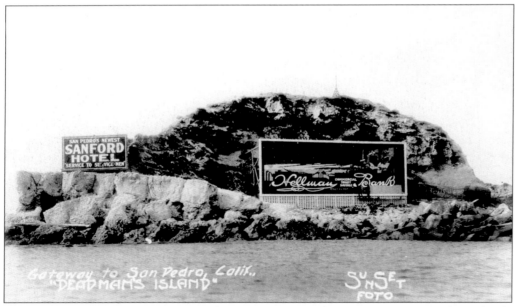

GATEWAY TO DEADMAN'S ISLAND. This c. 1910 postcard has two interesting displays of early advertising billboards found on the island, "San Pedro's Newest Sanford Hotel—Service to Servicemen" and "Hellman Bank." (Photograph by Sunset, San Pedro.)

Two

THE WATERFRONT AREA

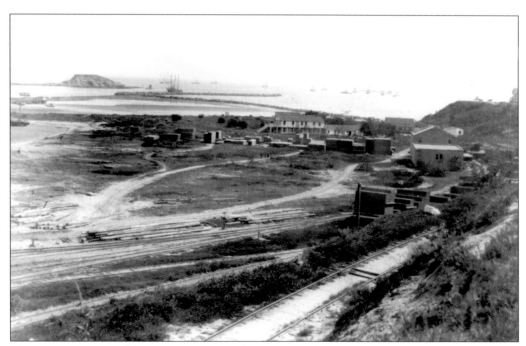

TIMM'S LANDING. This is a *c.* 1900 view of Timm's Landing, with its modest complex of hotel, warehouses, corral, and store. Bought by Capt. Augustus W. Timms in 1852, this was the original Sepulveda Landing, but over the years it came to be called Timms Point.

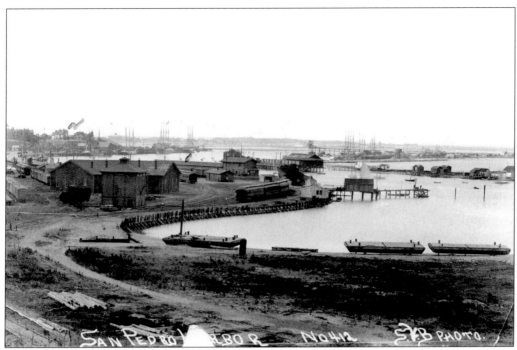

SAN PEDRO BAY, C. 1900. The message on the back of this postcard showing San Pedro Bay and Harbor reads, "The harbor we crossed to San Pedro from Terminal Island for dinner." (Photograph by Shirley V. Bacon.)

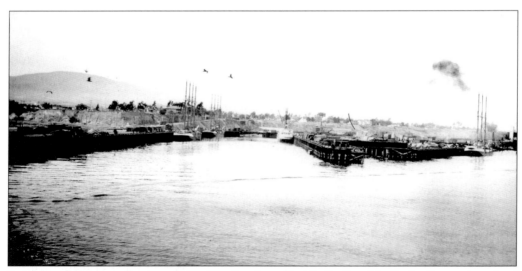

SOUTHERN PACIFIC SLIP, C. 1915. The Southern Pacific Railroad built the first major wharf in San Pedro. Dredging started in 1910, and the slip was completed in 1912. Arriving ships could unload their cargo onto waiting railroad cars onto one side of the slip. On the other side, railroad cars unloaded cargo for export onto waiting, outbound ships. This area is now Fisherman's Slip and is located next to Ports O' Call Village.

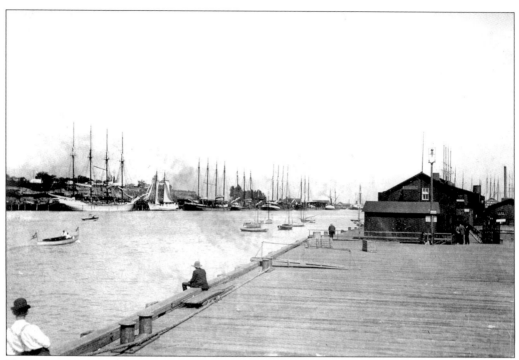

TERMINAL ISLAND LOOKING TOWARD SAN PEDRO. This postcard was mailed April 21, 1909. A lone man sits on the dock and looks across to San Pedro, where many tall ships were docked.

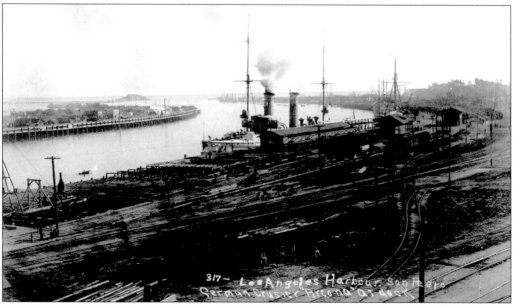

LOS ANGELES HARBOR, C. 1910. Near Fifth Street, the German Cruiser *Arcona* bellows smoke from one of it stacks. The wharf next to where the ship is docked is under construction.

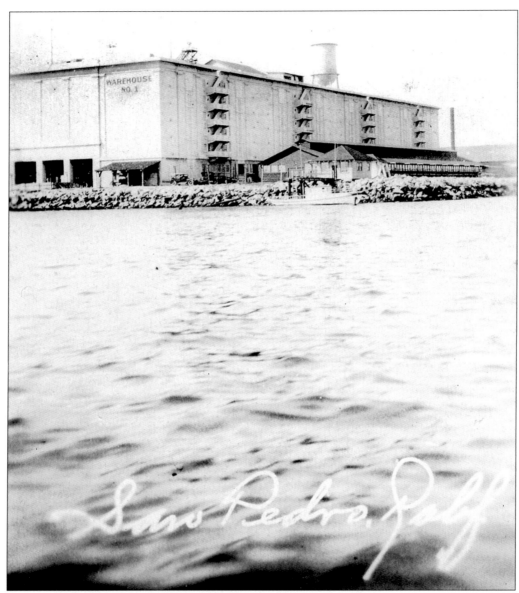

LOS ANGELES WAREHOUSE NO. 1. The construction of Warehouse No.1 was started in 1915 on the 60-acre Huntington Concession Municipal Pier No. 1, extending approximately three-fourths of a mile south from the Southern Pacific Slip. During the spring of 1917, the six-story warehouse containing a half-million square feet was completed. While it was estimated to take 8 to 10 months to build, construction actually lasted 19 months. The projected cost of $300,000 in 1915 was up to $475,792 by completion. The warehouse was officially listed in the National Register of Historic Places on April 21, 2000. Warehouse No. 1 served a leading role in warehousing in the harbor until the early 1970s, when cargo containerization revolutionized cargo handling. The Marine Exchange on the southeast corner of the roof of Warehouse No. 1 tracked harbor traffic from the 1920s until the 1980s. The Harbor Pilots building has replaced the building located next to the warehouse.

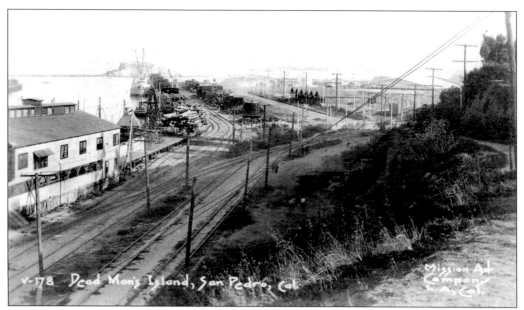

DOCKS AND DEADMAN'S ISLAND, C. 1910. The docks are stacked high with lumber from ships from the Pacific Northwest. Lumber was the main item imported during the first part of the 20th century for the growing Los Angeles area. (Courtesy of Mission Art Company, Los Angeles.)

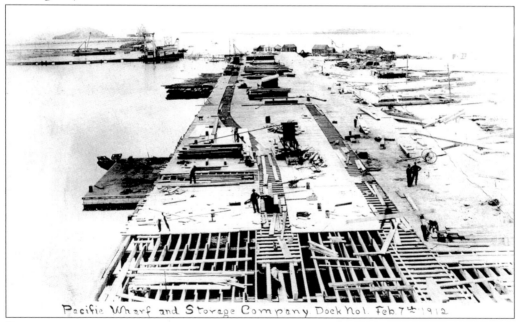

PACIFIC WHARF AND STORAGE COMPANY, DOCK NO. 1. This postcard, mailed on February 21, 1912, expresses anticipation of the opening of the Panama Canal: "Dear Jim—You see we are getting ready to land you in our docks just as soon as the Panama opens." Pacific Wharf and Storage Company was organized by John T. Gaffey. There are two dredges working on the channel between the wharf and Deadman's Island.

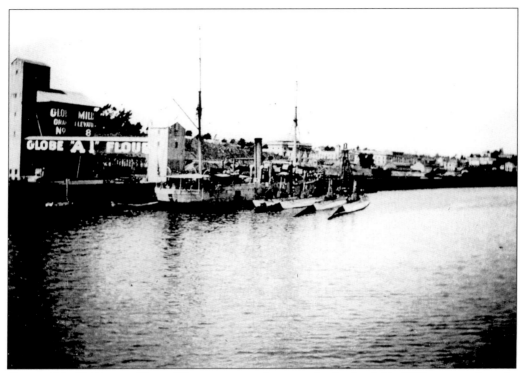

GLOBE "A-1" FLOUR MILL. The message written on the back of this 1920s postcard reads, "U.S.S. Alert and Submarines at San Pedro." Today, along this section of the channel (about Ninth Street), there are several restaurants and the start of the Ports o' Call Village area.

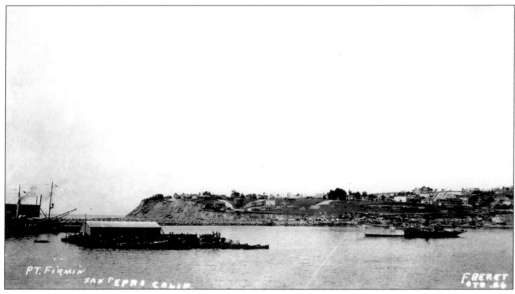

POINT FERMIN. This *c.* 1920s view from outer harbor looks southwest toward Point Fermin and the breakwater. With the completion of the breakwater, there was no sand yet to make up the future site of Cabrillo Beach. (Freret, OTO.26)

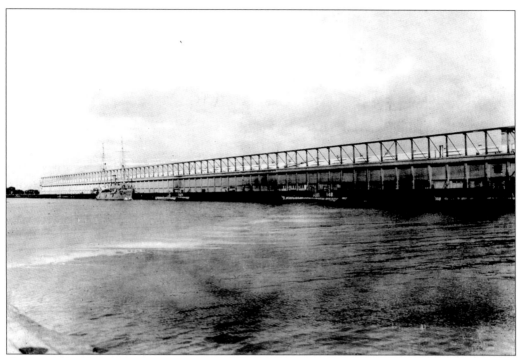

CITY OF LOS ANGELES, ONE-STORY TRANSIT SHED. This *c.* 1920s view of the Transit Shed building was built just west of Warehouse No. 1 on the Huntington Fill along the East Channel. Until 1923, the building also served as the base for the U.S. Navy's submarine fleet.

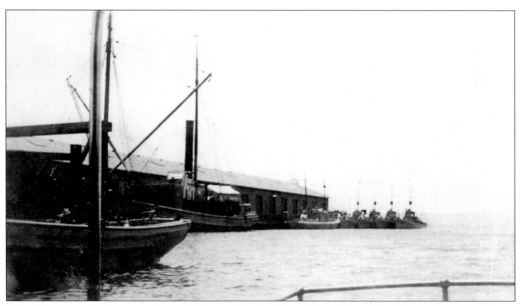

BUSY STORAGE TRANSIT SHED, EARLY 1920s. Several vessels are lined up and moored along side one of the storage transit sheds in the Los Angeles Harbor.

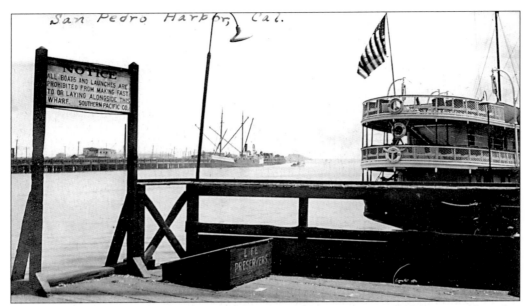

STEAMSHIP HERMOSA AT DOCK, 1920s. The sign on the dock reads, "All boats and launches are prohibited from making fast to or laying alongside this wharf. Southern Pacific Co." This was the 1920s way of saying "Stay away!"

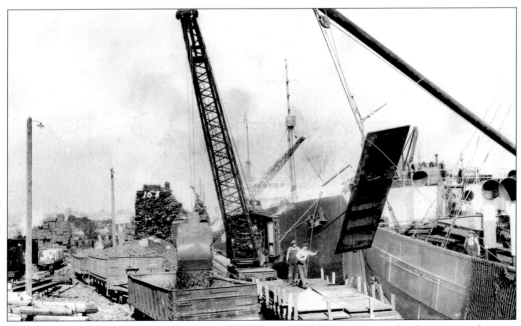

HARBOR ACTIVITIES. This 1920s view shows men working hard to unload cargo to place on a train car, while a steam shovel loads other train cars, and lumber is stacked high everywhere.

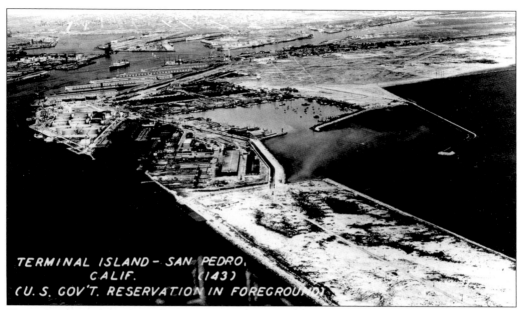

TERMINAL ISLAND. This *c.* 1928 view shows Fish Harbor on Terminal Island (the square area in the center of the photograph). The newly constructed U.S. Government Reservation area was made from Deadman's Island being removed to widen and deepen the main channel to aid navigation in the harbor. (Courtesy of Watson Airfotos, Long Beach.)

MAIN CHANNEL FROM WAREHOUSE NO. 1. This 1920s postcard has a message that reads, "View of ship channel to inner harbor, San Pedro from top of Los Angeles Harbor Department Warehouse." The view looks across the main channel northeast, toward Deadman's Island.

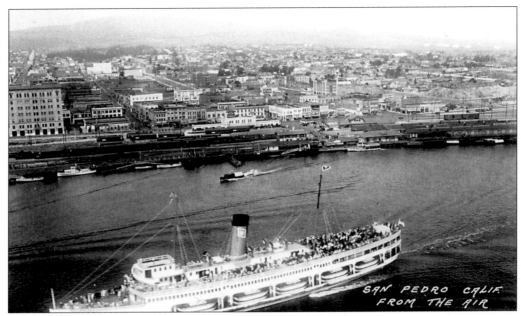

STEAMSHIP *CATALINA* IN MAIN CHANNEL. The SS *Catalina* sails out of the main channel on its daily trip to Avalon on Santa Catalina Island. It is seen passing in front of the Municipal Building (City Hall) and the Fifth Street ferry landing, among the numerous buildings of downtown. This postcard was mailed on July 24, 1936.

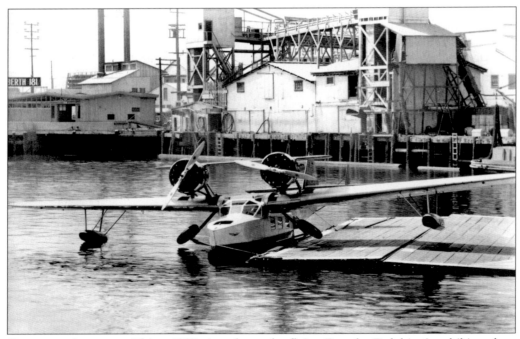

CATALINA AIRLINES. This *c.* 1935 view shows the flying Douglas Dolphin Amphibian plane next to Berth 181 in the Port of Los Angeles. Wilmington–Catalina Airlines operated this service in San Pedro Bay from 1931 to 1946.

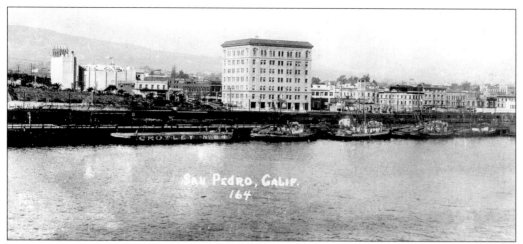

MUNICIPAL BUILDING FROM TERMINAL ISLAND, C. 1930S. Looking across the main channel at the ships tied up at the docks in San Pedro, the Fox Cabrillo Theatre (no longer there) is to the left of the Municipal Building, which is still used today for City of Los Angeles' offices and the San Pedro Bay Historical Society archives and offices.

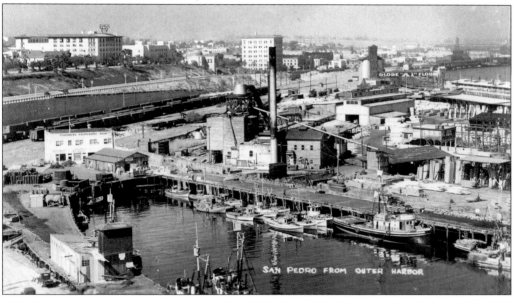

BUSTLING SEA PORT TOWN. This postcard was mailed July 16, 1943. Seen from the outer harbor, this view shows Fisherman's Slip in the foreground, with fishing boats and the Fishermen's Co-op Building (now Utro's Café). Beyond that are the train tracks, Harbor Boulevard and Beacon Street, and the YMCA building that was built in 1925 (in the background, above left). To the right of the YMCA is the Federal Building, built in 1935 and housing the post office, U.S. Customs, and other offices. Fainly seen is a domed building that was the Carnegie Library, built in 1906 and demolished about 1966. Beyond that is the Municipal City Hall Building, dedicated in 1928. Alongside Fisherman's Slip is the E. K. Woods Lumber Company, filled with imported lumber from the Pacific Northwest. Finally, on the right in the distance are the grain towers of Globe "A-1" Flower Mill. Both E. K. Woods and Globe A-1 have been replaced now by Ports-o'-Call Village and its parking lot.

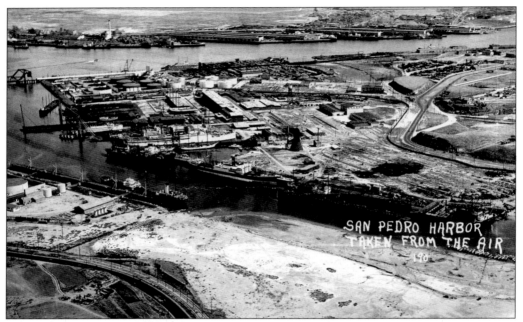

SMITH ISLAND FROM THE AIR. This postcard, mailed on March 7, 1945, shows a large piece of land that used to be Smith Island but is now connected to the mainland (the triangular piece of land in the center). This is also where Todd Shipyard was located for years. The Todd Shipyard was originally the Los Angeles Shipbuilding and Drydock Company. Also visible are the Pacific Electrics Bascule Bridge (above left), Standard Oil Compan,y and Kerckoff-Cuzner Mill and Lumber Company.

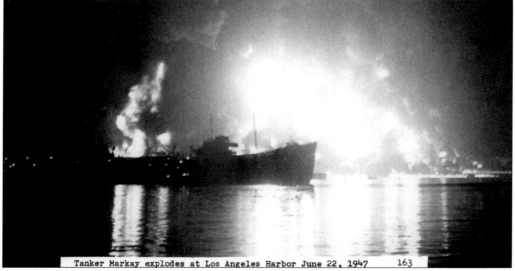

Tanker Markay explodes at Los Angeles Harbor June 22, 1947 163

TANKER *MACKEY.* The tanker ship *Markay* was at Berth 166, which belonged to Shell Oil Company, when the explosion happened. The Shell Oil berth was part of the Marine Oil Terminal located on Mormon Island. In the 1960s, Matson line used that site. The tanker was estimated to be filled to 60 percent capacity when it exploded at 2:06 a.m. on Sunday morning, June 22, 1947.

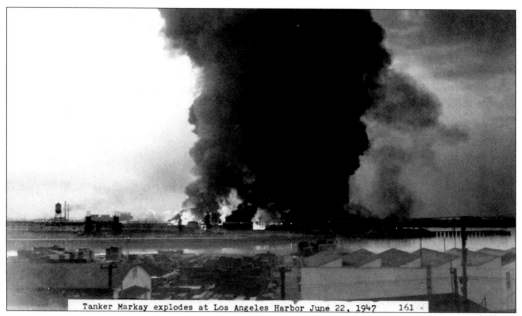

PLUME OF SMOKE AFTER EXPLOSION. Another view shows the explosion of the tanker *Mackay,* in which 10 people were reported killed and 2 people missing. It was reported that 19 engine companies, 3 truck companies, 3 fire boats, 2 boat tenders, 1 Coast Guard boat, and 1 Navy fire boat rendered assistance in fighting the fire.

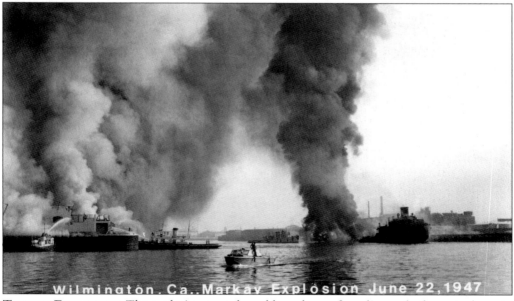

TANKER EXPLOSION. The explosion caused a sudden release of gasoline and other petroleum to spread rapidly over the surface of the water to several other berths on both sides of the channel up to a distance of 1,200 feet.

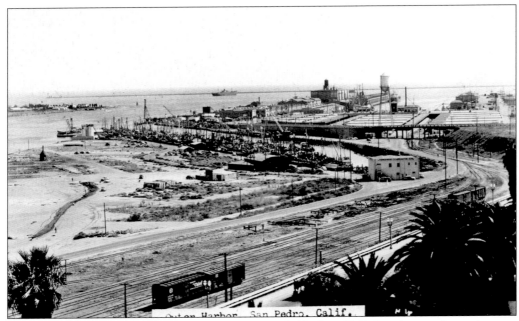

OUTER HARBOR. This 1940s view shows an empty field where E. K. Lumber was located—now the site of Ports o' Call Village and parking lot. Fisherman's Slip, packed full of fishing boats here, is still being used today but by far fewer fishing boats.

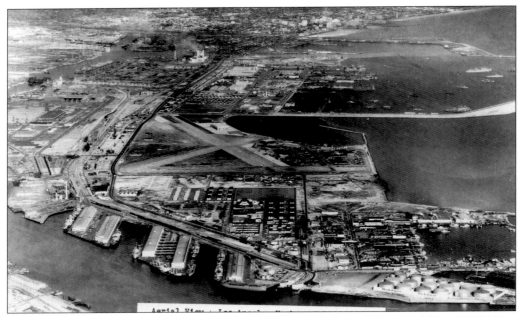

AERIAL VIEW OF TERMINAL ISLAND. This *c.* 1947 aerial view of Terminal Island (Old East San Pedro) and Fish Harbor looks east toward Long Beach. Note the runways of the Navy's Reeve's Field that make a cross in the center of the photograph.

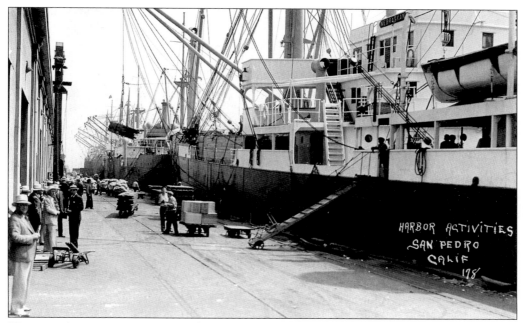

HARBOR ACTIVITIES. Many people wait dockside for the unloading of the lumber from these ships, including the *Nebraskan* (in the foreground).

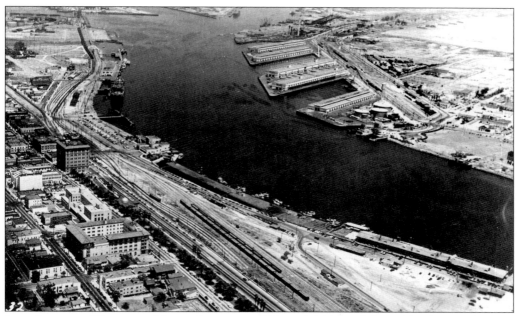

LOS ANGELES HARBOR, MAIN CHANNEL. This aerial view of the 1,000-foot-wide main channel of Los Angeles Harbor, was mailed on June 8, 1953. It contained the following message: "Bonnie is better for a day or so then she isn't. William enters the Navy Hospital today, Drs. say it is just nerves."

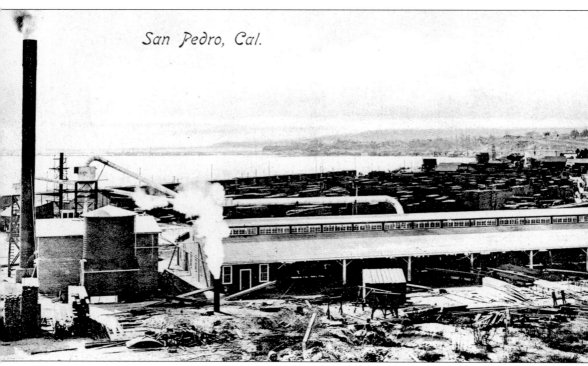

San Pedro, Cal.

SAN PEDRO HARBOR. This folding postcard showing a panoramic view of the harbor was mailed on May 28, 1906, with the message "Happy New Year to all. We have moved into our new home it's a fine house. I can send you a photograph if you don't visit this spring. Best to

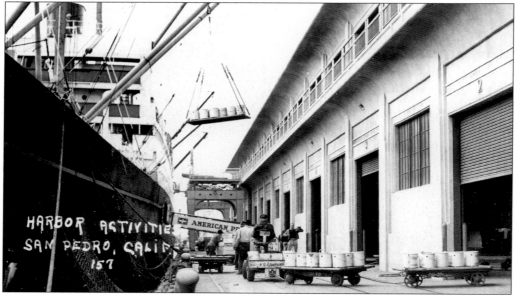

HARBOR ACTIVITIES. This 1950s view shows longshoremen moving cargo out of a Los Angeles Harbor storage shed onto the dock. Afterwards, other longshoremen will load it onto the waiting American President Line ship.

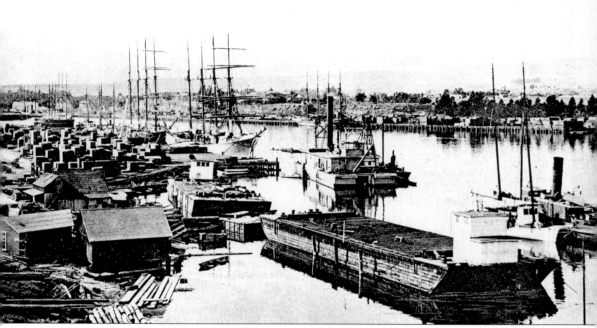

all." Rattlesnake Snake Island (later changed to Terminal Island) with its lumber plant looks overloaded with lumber. Looking toward the city of San Pedro, visible are two barges (in the foreground), a harbor dredge, and several other tall sailing ships.

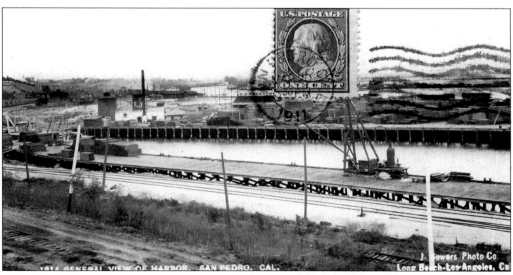

GENERAL VIEW OF HARBOR. This postcard was mailed March 20, 1911. "San Pedro Harbor View" was the entire message. The postage stamp and cancellation mark are on the picture side of this postcard, not the address side. This is the new Southern Pacific Railroad Slip built next to Timms Landing. (Courtesy of J. Bowers Photo Company, Long Beach–Los Angeles, California.)

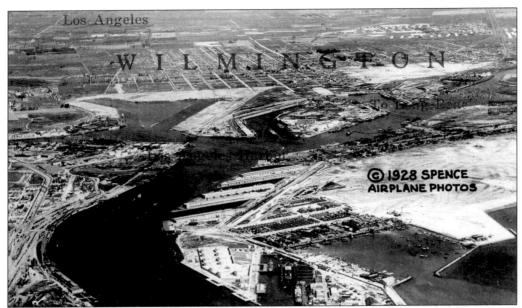

INNER HARBOR, WILMINGTON AREA. This 1928 postcard is an aerial view of the inner harbor with San Pedro, Wilmington, and Terminal Island. This is a good example of a promotional advertising card for Wilmington, the "fastest growing port in the world." The backside of this card grabs one's attention with the word "INVESTIGATE." It continues by listing other statistics like population (2,250 in 1920 and 15,000 in 1928) and steamship lines numbering 25 in 1920 and 94 in 1928. (Copyright 1928, Spence Airplane Photos.)

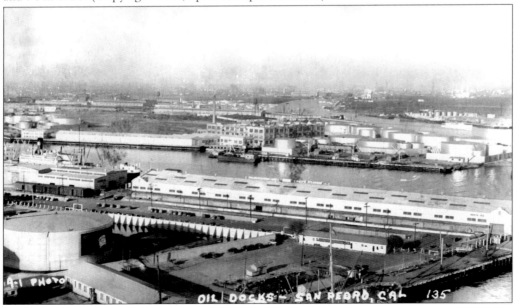

SHELL OIL DOCKS, C. 1940s. Pictured are the Shell oil docks at Berth 167 on Mormon Island in the inner harbor. Across the channel from the oil docks is the building for the Dollar Steamship Line (the long, light-colored building in the foreground) and the Pacific Steamship Company on Smith Island. (Courtesy of A-1 Photo.)

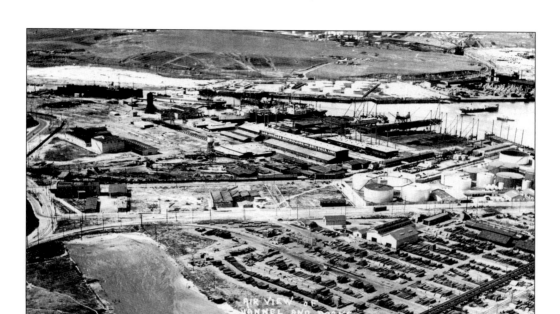

SMITH ISLAND AND WEST BASIN. This 1925 view shows the area that was Smith Island before land filling connected it to the mainland. In the foreground is Boschke Slough, next to the Kerckhoff-Cuzner Mill and Lumber Company. Above center is the Los Angeles Shipbuilding and Drydock Company that later became Todd Shipyard.

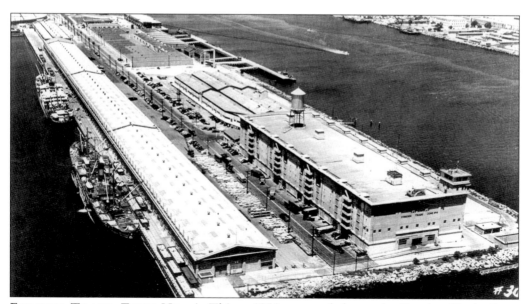

FOREIGN TRADE ZONE NO. 4. This *c.* 1950 postcard shows the Foreign Trade Zone No. 4 with Warehouse No.1 and Los Angeles storage Transit Shed. This is where foreign merchandise was landed, stored, re-exported, and manufactured without payment of duty, pending reshipment of goods aboard or entry into the United States.

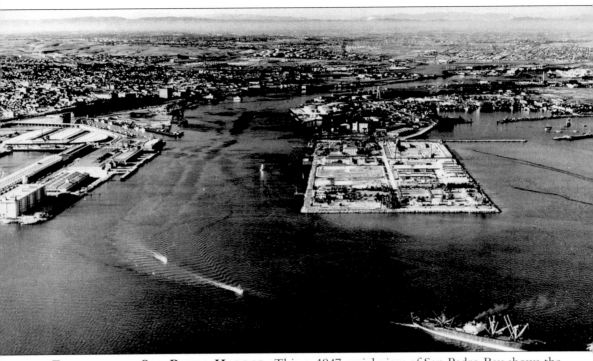

ENTRANCE TO SAN PEDRO HARBOR. This c. 1947 aerial view of San Pedro Bay shows the 1,000-foot-wide main channel coming into the harbor. On the left side of the channel is Warehouse No. 1. On the right side is the Government Reservation Point and Fish Harbor.

Three

FERRIES, BRIDGES, AND DRYDOCKS

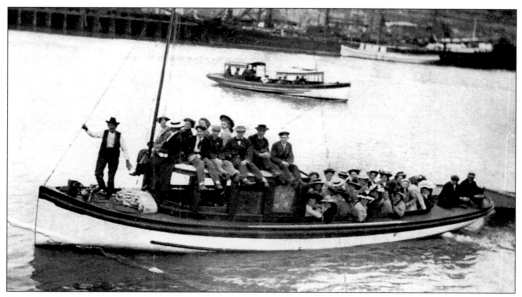

POWER LAUNCH *EMILINE*. This 1909 view shows a launch filled with passengers and crossing the channel between San Pedro and East San Pedro on Terminal Island. The message on the back of the postcard reads, "The *Emiline* is Safe-Roomy-Comfortable and equipped with plenty of trolling tackle. Specialist in fishing parties, outings and Island cruises based in East San Pedro CA. W. G. Luke."

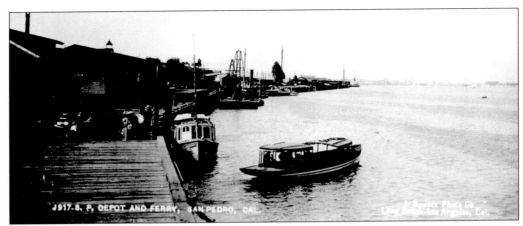

SOUTHERN PACIFIC DEPOT AND FERRY. Located near the Pacific and Electric Train Depot is the ferry dock at Fifth Street. The ferry launch *Blanche* (built in 1906) is heading toward the East San Pedro landing, 500 feet away. (Courtesy of J. Bowers Photo Company, Long Beach and Los Angeles.)

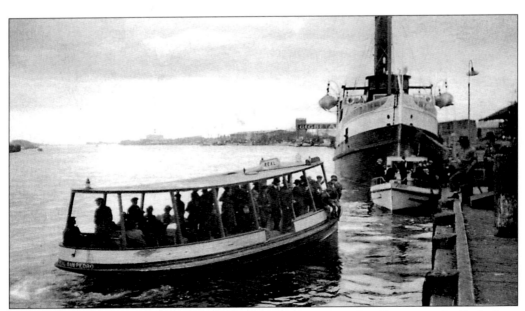

FERRY BOAT *REAL*. Built in 1913 for the San Pedro Transportation Company, the *Real*, along with the *Peer*, ferried passengers across the channel to East San Pedro on Terminal Island. These ferries were relegated to standby duty in 1925, when they were replaced by larger boats. (Published by Western Publishing and Novelty Company, Los Angeles.)

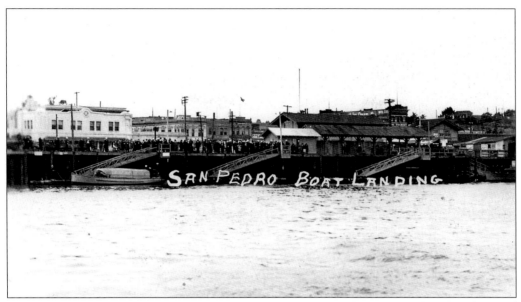

BOAT LANDING, FIFTH STREET. This *c.* 1910 view shows a dock crowded with sailors and civilians waiting for the ferries. The Pacific Electric Terminal (Red Car) building on Harbor Boulevard is the white building in the background.

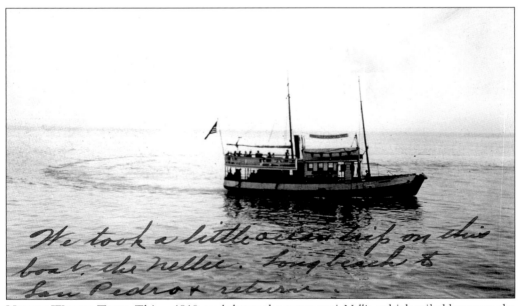

NELLIE WATER TAXI. This *c.* 1910 card shows the water taxi *Nellie,* which sailed between the ports of San Pedro and Long Beach. The message written on the front of this postcard is "We took a little ocean trip on this boat the *Nellie.* Long Beach to San Pedro & return."

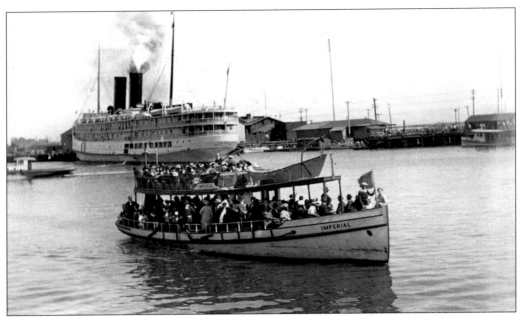

IMPERIAL FULLY LOADED WITH PEOPLE. This postcard was mailed July 1915 with the following message: "This is a picture of the harbor here with a crowd out for a boat ride. Certainly a fine day today. Think I will celebrate at Point Fermin Tomorrow." The *Imperial*, packed with people, is on a sightseeing trip, with the USS *Harvard* in background.

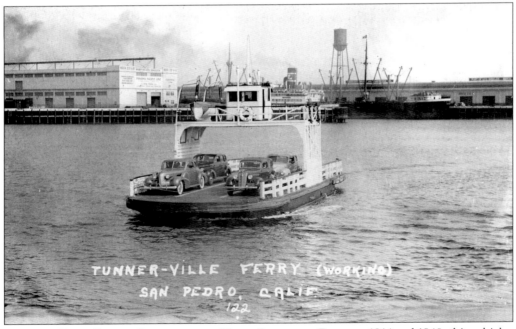

TUNNER-VILLE FERRY CROSSING THE MAIN CHANNEL. Between 1914 and 1940, this vehicle-carrying ferry crossed the channel from Terminal Island to San Pedro, between First Street in San Pedro and East San Pedro on Terminal Island.

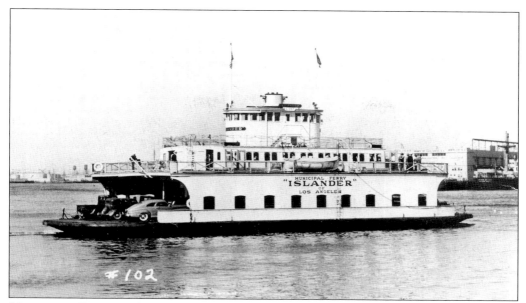

MUNICIPAL FERRY *ISLANDER*. Here is a *c.* 1950s view of the City of Los Angeles Municipal Ferry *Islander* that crossed the 1,000-foot-wide main channel of the harbor from 1941 to 1963. Its vehicle-carrying capacity had definitely increased from its predecessor, the Tunner-ville ferry.

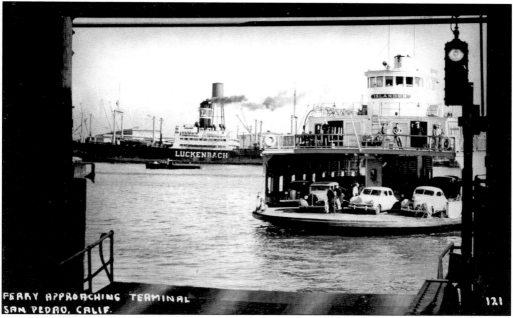

ISLANDER **APPROACHING TERMINAL.** This *c.* 1950s view from the inside of the ferry building is what waiting passengers would see as they waited for the *Islander* to arrive. The ferry carried vehicles on the deck while passengers rode topside. Here the cargo ship *Luckenbach* is passing behind the ferry.

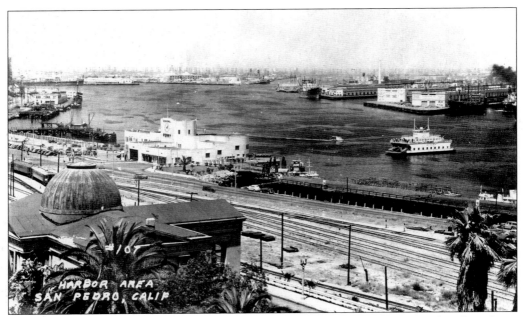

FERRY BUILDING. The Public Works Administration (PWA) created this Streamlined Moderne building in 1941 as a base for an auto ferry crossing the channel at regular intervals from San Pedro to its sister building on Terminal Island. The roof of the Carnegie Library is visible in the foreground.

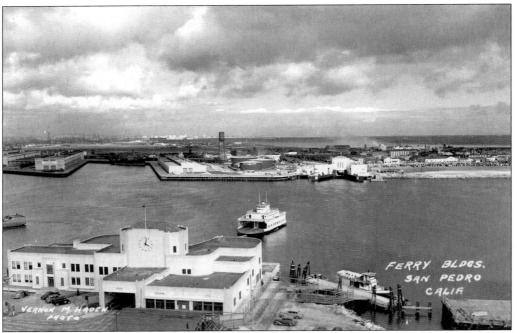

AERIAL VIEW OF BOTH FERRY BUILDINGS. The ferry service provided people a shorter route to Terminal Island or Long Beach, rather than the long circular route through Wilmington and industrial Long Beach. (Photograph by Vernon M. Haden.)

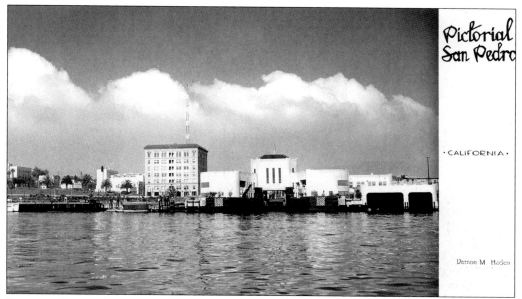

BACK OF FERRY BUILDING. This is a view of the back of the Municipal Ferry building as you approached it from Terminal Island in the 1940s. To the left of the ferry building is the Municipal Building unofficially known as San Pedro City Hall, built in 1928. Next to the City Hall is the Fox Cabrillo Theatre and on the very far left is the corner of the United States Post Office building. (Photograph of Vernon M. Hader.)

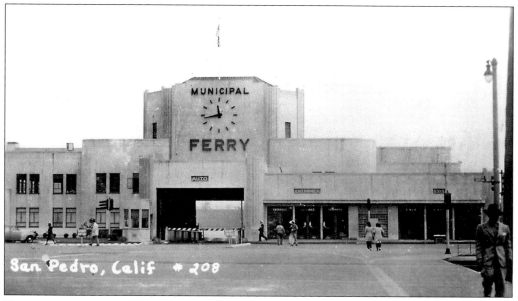

FRONT OF FERRY BUILDING. Pictured here in the 1940s, the Municipal Ferry building was saved from demolition in the 1960s. The 75,000-square-foot facility became home to the current resident, the Los Angeles Maritime Museum, and it is now Los Angeles City Historic-Cultural Monument No. 146.

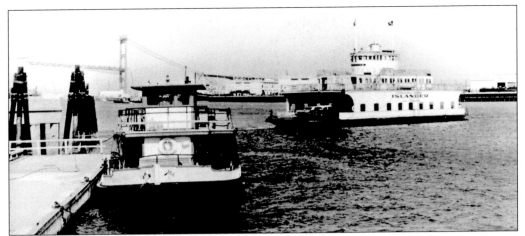

ISLANDER, LAST YEAR OF SERVICE. In November 1963, with the opening of the Vincent Thomas Bridge, the ferry ceased operations. The bridge, which now connects San Pedro to Terminal Island, can be seen under construction in the background of this image. The smaller pedestrian ferry *Ace* lies alongside the public landing. It only operated during rush periods and after midnight, when the *Islander* was shut down.

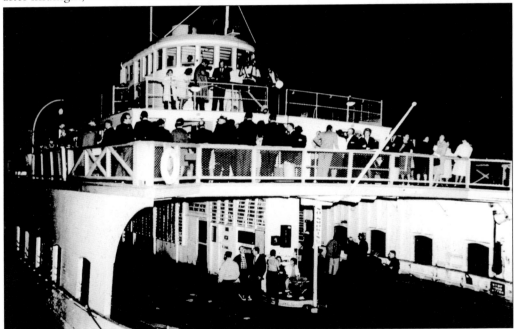

LAST CEREMONIAL RUN OF THE *ISLANDER*. On November 14, 1963, at 7:30 p.m., a banquet dinner for more than 300 people was held at the Yugoslav-American Club. The last trip of the ferry *Islander* took place at 9:30 p.m. for another crowd of over 300 people. On this trip, the ferry took a different route—down the Cerritos Channel and into Long Beach Harbor and back. Once the ferry had returned to the dock for the last time, the crowd assembled at the Vincent Thomas Bridge for the 11:45 p.m. ribbon-cutting ceremony. Assemblyman Vincent Thomas cut the ribbon then got on a bus with other dignitaries and led a 100-car caravan across the bridge. The bridge opened to public traffic at midnight, with a toll of 25¢ per vehicle.

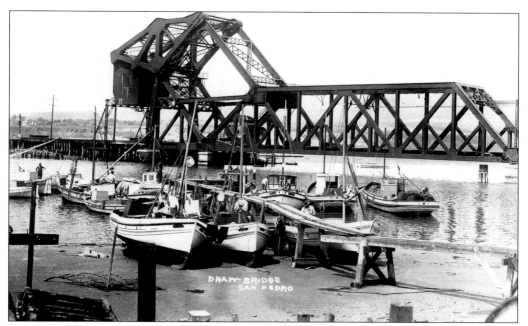

PACIFIC ELECTRIC DRAWBRIDGE. This 1912 postcard is of the Pacific Electric Strauss Bascule Bridge, which provided rail access to San Pedro Harbor from Wilmington between 1910 and 1957. The bridge spanned the turning basin near what is now the west side of the Vincent Thomas Bridge.

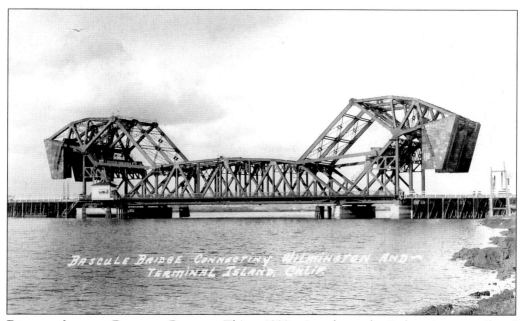

BADGER AVENUE BASCULE BRIDGE. This *c.* 1930s view shows the Badger Avenue railroad bridge that connected Wilmington to Terminal Island. Built in 1924, it was also known as the Henry Ford Bridge. A newer railroad bridge replaced it in 1996.

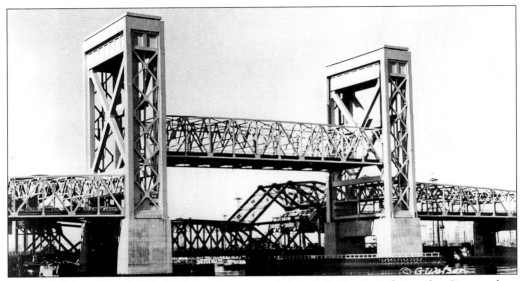

Two Bridges Crossing Cerritos Channel. A *c.* 1950s view shows the Commodore Schuyler F. Heim Bridge (Terminal Island Freeway Bridge) built in 1946. The other bridge that is closed is the Badger Avenue Bridge, built in 1924 and also known as the Henry Ford Bascule Bridge. (Courtesy of G. Watson.)

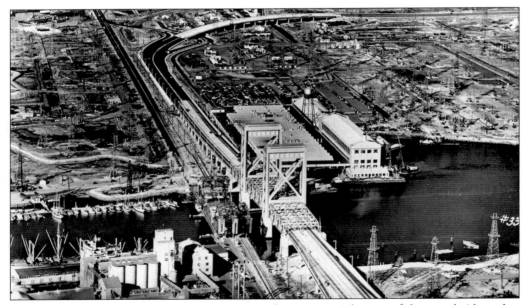

Bridges Crossing Cerritos Channel. This is an aerial view of the two bridges that cross the Cerritos channel to connect Wilmington to Terminal Island. Visible to the right of the bridge is the old Ford assembly plant that was demolished years ago to make way for new harbor development.

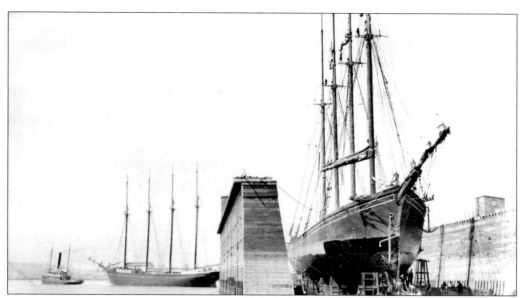

DRY DOCK, CRAIG SHIPYARD. This postcard depicts an old sailing ship in dry dock for repairs, c. 1910.

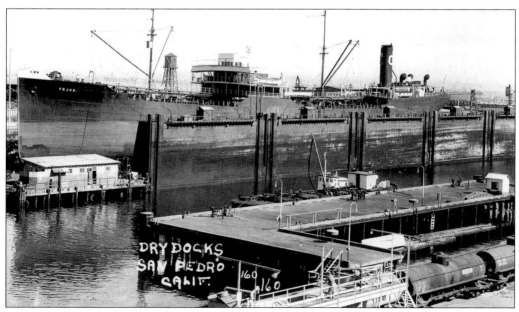

DRY DOCKS IN SAN PEDRO. The ship *Tejon* is pictured in dry docks for work. This postcard was mailed July 8, 1946, to "Barry Neufer, Fresno, Calif." The message reads, "We had a good time in Hollywood and today we saw the helicopter plane bring the first air mail into San Pedro."

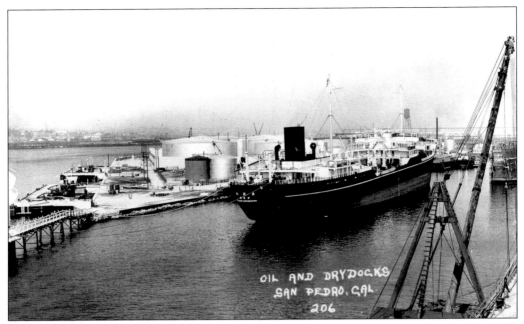

OIL AND DRY DOCKS. This *c.* 1950s postcard provides a partial view of the dry dock, on the right. The oil tanker is tied next to the oil tanks on Terminal Island.

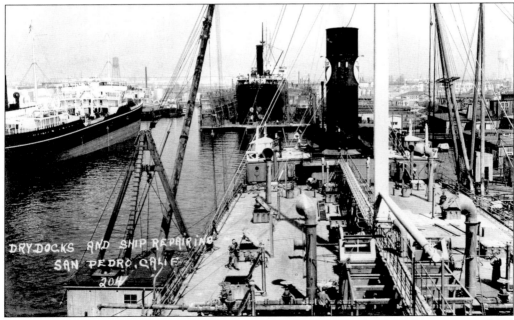

DRY DOCKS AND SHIP REPAIRING, *C.* 1950S. A Texaco oil tanker is in for repairs. Behind it, another tanker in dry dock is being worked on.

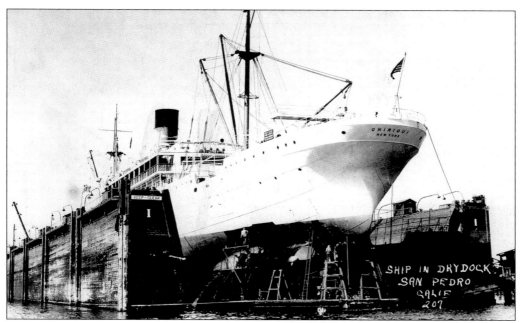

SHIP IN DRYDOCK. This *c.* 1940s shows the cargo ship *Chiriqui,* from New York, in for repairs. The ship was built in 1932 for the United Fruit Company, along with its twin cargo ship, the *Quiriqua.*

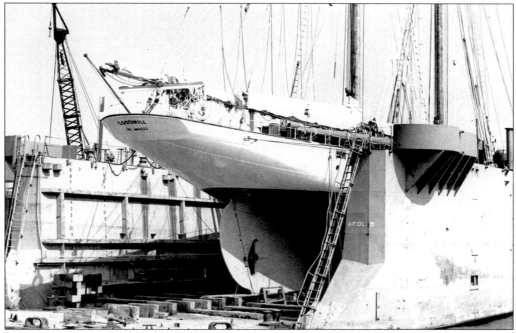

***GOODWILL* IN DRYDOCK** This *c.* 1950s view shows the yacht *Goodwill* getting an overhaul in the dry docks of Fellows and Stewart Company on Terminal Island. (Courtesy of Crawford.)

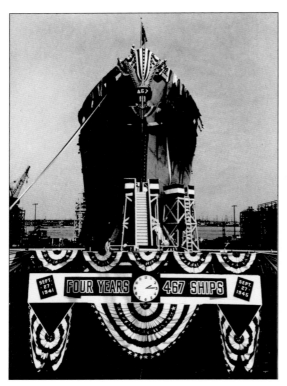

FOUR YEARS, 467 SHIPS. Between September 27, 1941, and September 27, 1945, the Cal shipyard on Terminal Island built 467 cargo ships. The shipyard built 131 Victory ships and 336 Liberty ships. This 1945 postcard features one of the cargo ships built at the shipyard during World War II.

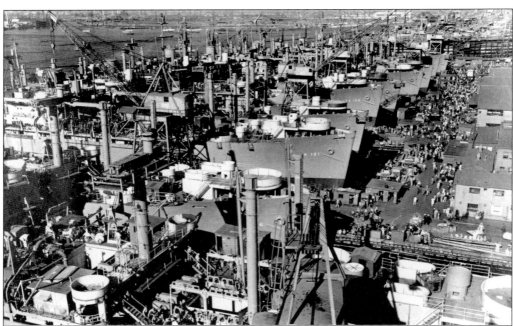

CAL SHIPYARD. This 1944 view shows several hundred men on the dock who are working on the 30 attack transports that were built for the U.S. Navy in 1944 at the Cal shipyard on Terminal Island.

Four

FISHING

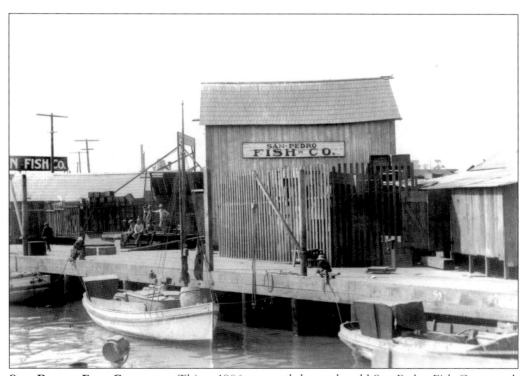

SAN PEDRO FISH COMPANY. This *c.* 1906 postcard shows the old San Pedro Fish Company's building. Several men sit around—probably on a coffee break—and three small boats are tied to the dock.

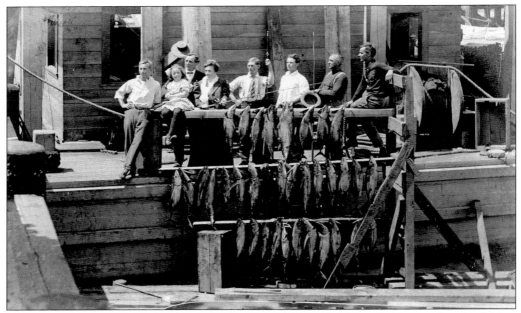

MEMORABLE CATCH IN SAN PEDRO. There's obviously a good reason to remember the fishing expedition in this photograph mailed July 17, 1909, from San Pedro to W. J. Hrusel. The message reads, "How is this for a catch? Wish you could have been with us Albert."

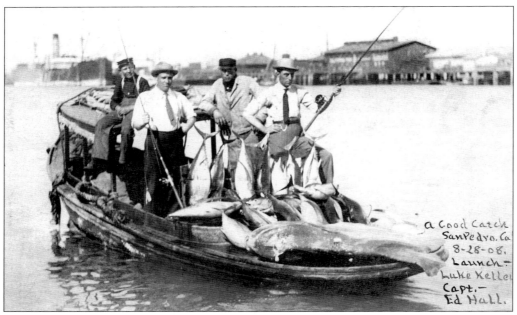

PROUD FISHERMEN ALL DRESSED UP. The front of the postcard reads, "A good catch San Pedro Ca 8-28-08 Launch—Luke Kelly Capt.—Ed Hall," it is apparent from their catch that these fishermen had a good day in this rather small water taxi.

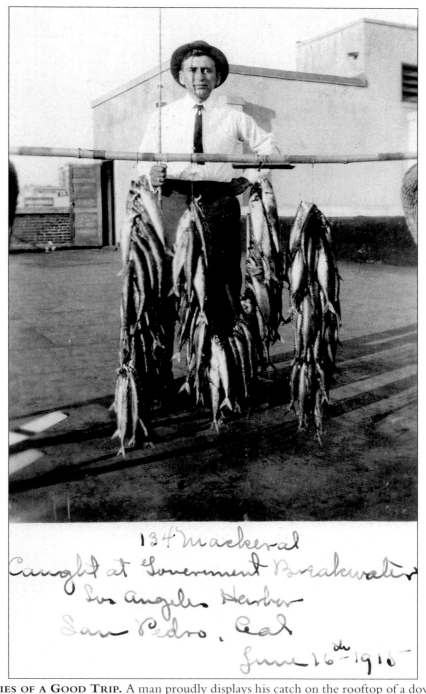

TROPHIES OF A GOOD TRIP. A man proudly displays his catch on the rooftop of a downtown building. The handwritten caption reads, "134 mackeral [*sic*] caught at Government Breakwater Los Angeles Harbor San Pedro, Cal, June 16th—1915." The message on the back reads, "A few days before that we caught 90 and about a week later we caught 142 just the two of us were fishing." This postcard was never mailed.

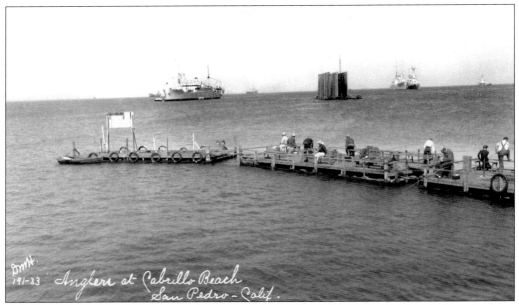

ANGLERS AT CABRILLO BEACH. This view from the fishing pier off of the breakwater (looking east) shows the harbor with one of the Navy's hospital ships anchored in the outer harbor. Also, to ship's right, is a large structure that the Navy used for target practice.

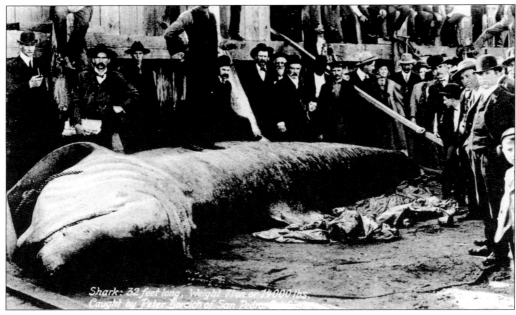

FAMOUS SHARK. This photo postcard, more commonly seen in lithograph postcards, shows a group of people posing with an unusual catch. The front of the postcard reads, "Shark 32 feet long, weight 2 tons or 1400 lbs. Caught by Peter Borcich of San Pedro of San Pedro Calif."

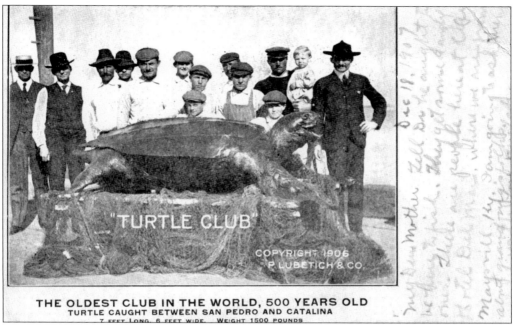

"TURTLE CLUB," THE OLDEST CLUB IN THE WORLD. This turtle, caught between San Pedro and Catalina, was seven feet long, six feet wide, and weighed 1,500 pounds. The postcard was mailed December 19, 1907, to Mrs. L. W. Fearherley in Mt. Carmel, Illinois. The message reads, "My Dear Mother, Tell Dr. he ought to be here to fish. They get some mighty big ones. There are people here at Hotel Del Mar where we are from Marysville KY. I am going to ask them about grandma's folks. With Love, Beulah." (Courtesy of P. Lubetich and Company.)

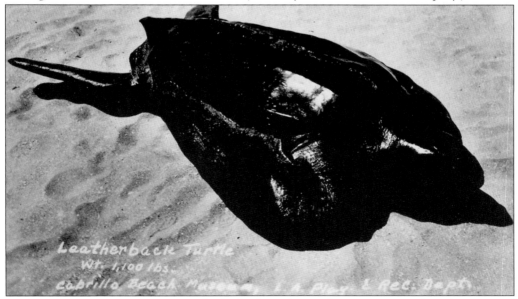

ON THE SAND IN SAN PEDRO. A leatherback turtle weighing 1,100 pounds is the center of interest at the Cabrillo Beach Museum, managed by the Los Angeles Department of Playground and Recreation, as stated on the card.

FISHERMENS
"RETREAT"

LV. 22ND ST. DOCK SAN PEDRO, 2:30 A.M DAILY

FISHING COASTAL AND ISLAND WATERS

RADIO TELEPHONE W.P.V.C 28 BERTHS LUNCH SERVICE AT SHORE PRICES

CAPT. DICK CRANK OWNER FOR RESES. PHONE S.P. 6363 OR LOMITA 741 "STAN" SAYLES SKIPPER

WINTER CHARTERS TO ??

FISHERMEN'S "RETREAT." This is a *c.* 1930s advertising postcard for the sportfishing boat *Retreat*. It was at the 22nd Street dock, Berth 28, sailing daily at 2:30 a.m. and fishing coastal and island waters. The owner was Capt. Dick Crank, and the skipper was "Stan" Sayles.

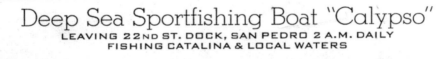

Deep Sea Sportfishing Boat "Calypso"
LEAVING 22ND ST. DOCK, SAN PEDRO 2 A.M. DAILY
FISHING CATALINA & LOCAL WATERS

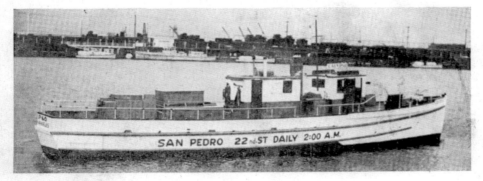

RADIO TELEPHONE W.P.V.B 20 BERTHS LUNCH SERVICE AT SHORE PRICES

HARRY EVANS OWNER & OPER. FOR RESERVATIONS: PHONE S.P. 6363 OR 3814 BULL BASS RED FISH CAPTAIN

CALYPSO SPORTFISHING BOAT. This is a *c.* 1930s advertising postcard for the deep sea sportfishing boat *"Calypso."* It was at 22nd Street dock, Berth 20, sailing daily at 2 a.m. and fishing Catalina and local waters. The owner and operator was Harry Evans, and the fish captain was Bull Bass Red, as referenced on the card.

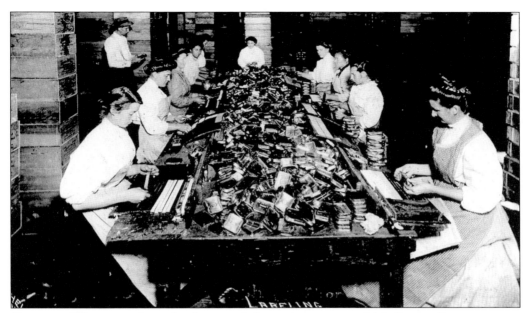

CANNERY WORKERS. An early photograph shows women at work labeling sardine cans at one of the area's many canneries. With the absence of modern machinery, women from the nearby communities of Terminal Island, San Pedro, and Wilmington did most of these jobs.

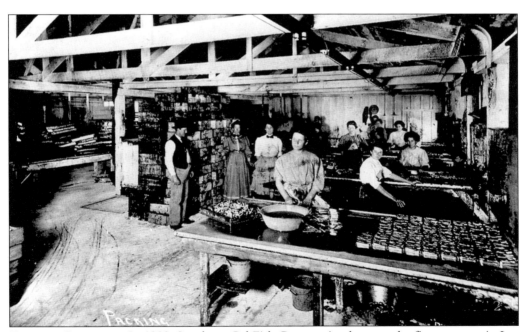

PACKING SARDINES. In 1892, Southern Cal Fish Corporation became the first cannery in Los Angeles Harbor. In 1903, a technique of preparing and canning was developed to can sardines, mackerel, bluefish tuna, yellowfin tuna, and albacore. This view is of the inside of the canning room, where women spent long, arduous hours enveloped by the aroma of fish.

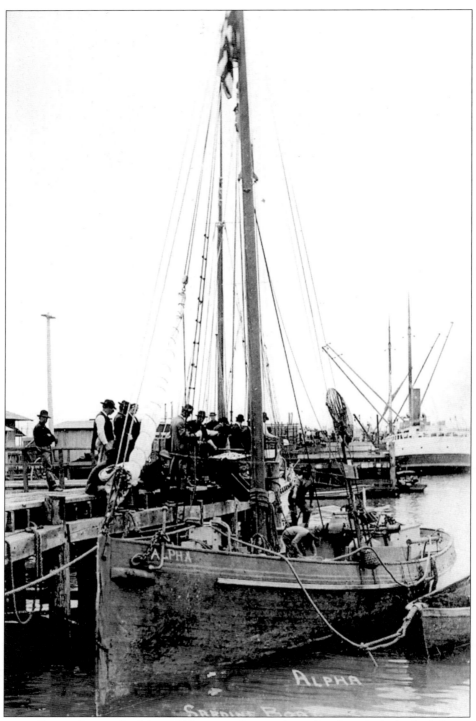

SARDINE BOAT *ALPHA*. In this *c.* 1910 postcard, an early sardine boat is docked while men in suits look at the sardines pointed out by the man on the boat.

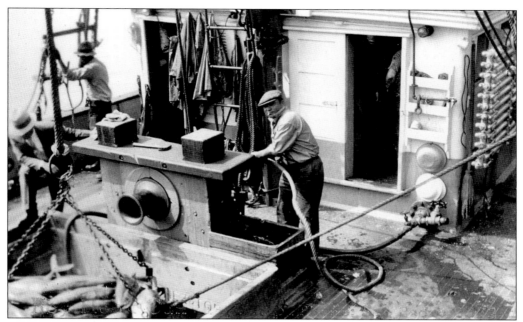

UNLOADING FISH, *c.* **1920s.** A man dressed in a suit checks the load of tuna being removed from the hole of the fishing boat, while a rugged-looking deckhand stands nearby.

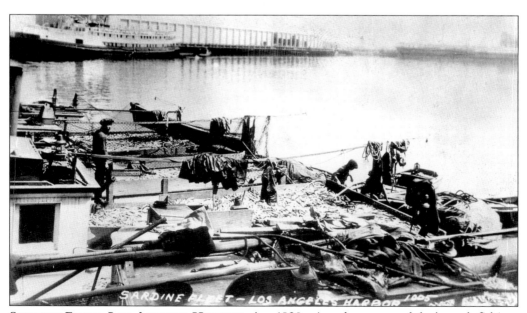

SARDINE FLEET, LOS ANGELES HARBOR. A *c.* 1920s view shows a good day's work fishing, including four boats filled to capacity with sardines to be unloaded for processing at the cannery. The passenger ship *Hermosa* is docked at one of the port warehouses in the harbor.

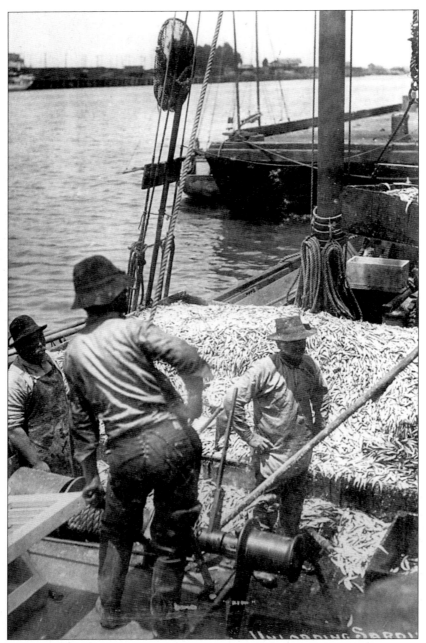

UNLOADING SARDINES. In this *c.* 1910 view, three men pause before unloading a full boat of sardines. Along with Pacific sardines, vast schools of tuna and anchovies were caught in the nearby waters. The fishing industry in San Pedro was originated primarily by European and Japanese fishermen, each bringing fishing knowledge from their native lands. By 1920, there was a large fleet of fishing boats and methods of fishing such as purse seine, lampara, jig, live bait, gill net, mackerel scoopers, and long-line boats. San Pedro became the largest fishing port in the nation, with the industry at its peak during World War II. During the 1950s, the fish populations diminished, causing the decline of the fishing industry here.

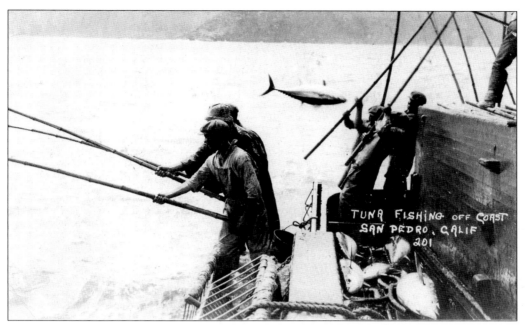

TUNA FISHING OFF THE COAST OF SAN PEDRO. This *c.* 1900s postcard shows three-man teams using bamboo poles to haul in their catch of tuna, one fish at a time.

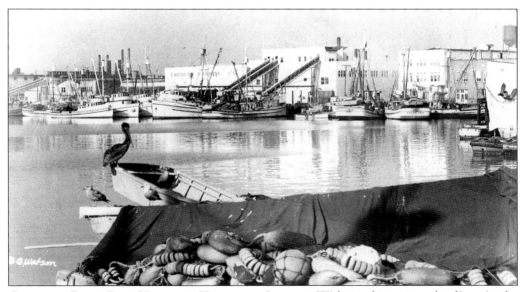

CANNERY ROW–FISH HARBOR, TERMINAL ISLAND. With an almost-posed pelican in the foreground, this image shows the fishing boats tied up in front of the cannery of the French Sardine Company. (Photograph by Golden West; courtesy of Gilmore Photo Laboratory, San Pedro.)

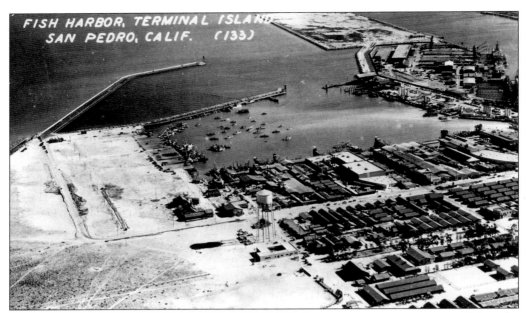

FISH HARBOR, TERMINAL ISLAND. The newly completed Reservation Point (1929) is at the top of this photograph. The rows of buildings (on the right in the foreground) were occupied by the Japanese community that lived at East San Pedro on Terminal Island before World War II. (Courtesy of Watson Airfotos, Long Beach.)

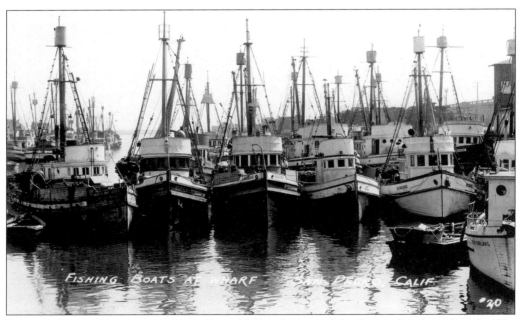

FISHING BOATS DOCKED AT FISH SLIP, 1930S. A view of the former Southern Pacific Slip, now called Fish Slip, shows the following purse seiners, docked from left to right: unidentified, *Southland, Success, MK1, Milwaukee,* and the *New England.*

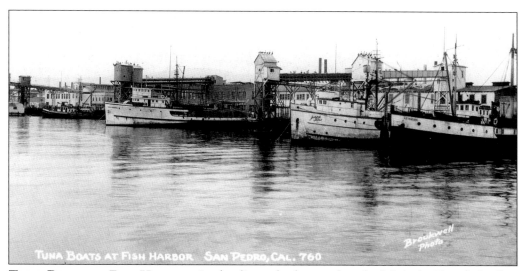

TUNA BOATS AT FISH HARBOR. In the distant background to the left is the French Sardine Cannery. At other canneries, boats including the *Jenny Rose* and the *Retriever* unload their catches. (Photograph by Brookwell.)

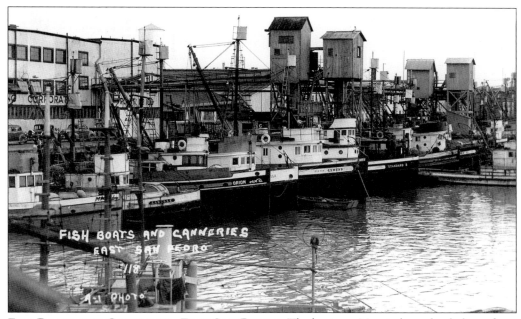

FISH BOATS AND CANNERIES, EAST SAN PEDRO. The boats waiting to be unloaded are, from left to right, unidentified, *Labelle, Orion, Ceneva, Standard I,* and *Western Spirit.* The high wooden structures in the background housed vacuum equipment that sucked the "wetfish" (sardines or mackerel) from boats to the cannery in 1930. (Photography by A-1.)

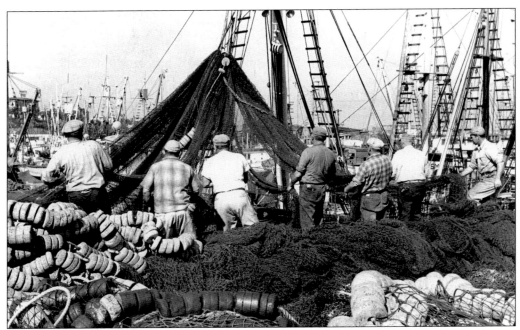

WORKING AT FISHERMAN'S SLIP. This *c.* 1950s view shows Fisherman's Slip, where a crew is working an enormous mound of fishing nets before they can return to the sea. About all you can see in any direction is purse seiners packed together like sardines.

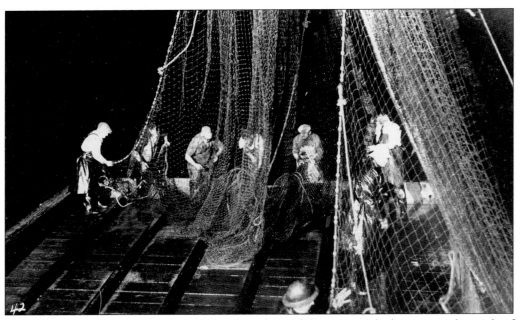

REPAIRING FISHING NETS. A *c.* 1950s view shows fishermen with the neverending job of mending their fishing nets. This grueling work had to take place daytime and nighttime to prepare for sea.

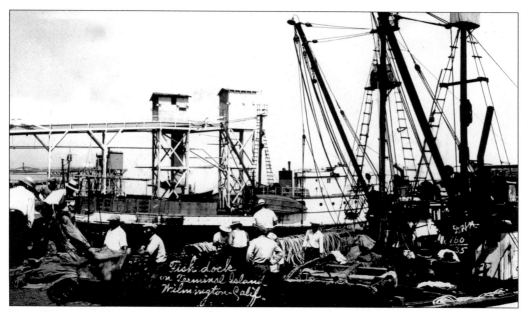

FISH DOCK ON TERMINAL ISLAND, WILMINGTON. In this *c.* 1930s view, several fishermen, having unloaded their catch at the canneries, prepare their nets and other equipment so they can return to the ocean. (DHA 160/35.)

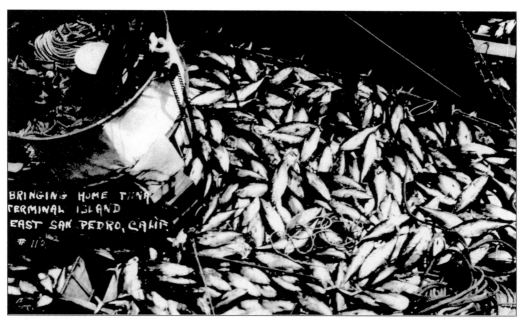

BRINGING HOME TUNA, TERMINAL ISLAND, EAST SAN PEDRO. This postcard, mailed February 28, 1948, to Phyllis Culp of Bellingham, Washington, has this message: "Just a line to let you know that we're all still in the fish business. Fred still catches them, Ruth & Miss Brown still eat them and I still count them—Ha! Orie Mae"

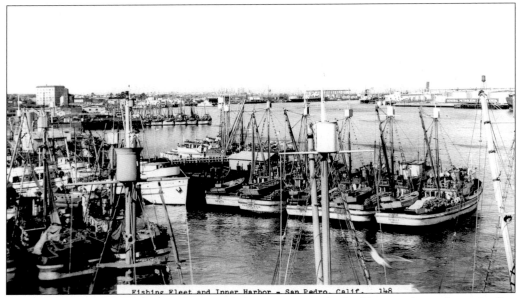

FISHING FLEET AND INNER HARBOR. This 1940s postcard is looking northeast down the San Pedro Channel. The large fishing fleet sits in the foreground, with the San Pedro Municipal building in the distance.

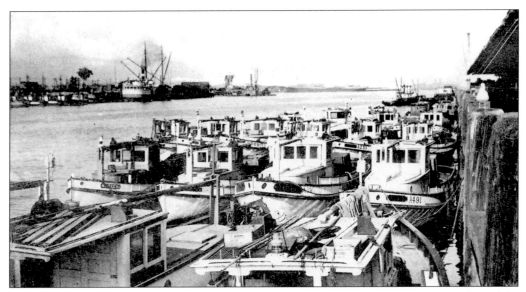

FISHING SMACKS, LOS ANGELES HARBOR. Pictured in this *c.* 1930s view are just a few of the many fishing boats that docked in San Pedro. (Courtesy of Western Publishing and Novelty Company, Los Angeles.)

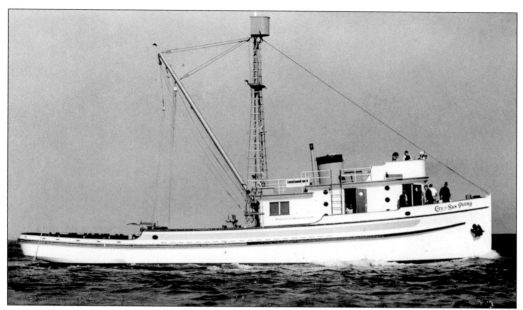

CITY OF SAN PEDRO. This is a classic 1950s shot of the fishing boat *City of San Pedro* during the height of the fishing industry in San Pedro. Fishermen took pride in their boats.

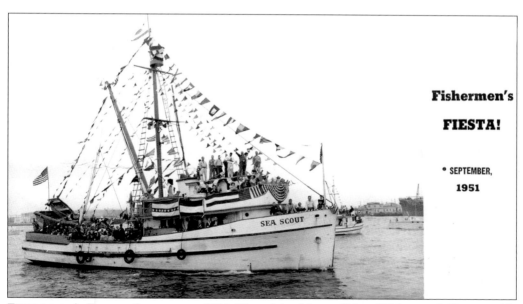

Fishermen's FIESTA!

• SEPTEMBER, 1951

FISHERMAN'S FIESTA, SEPTEMBER 1951. The spirit of the traditional Fisherman's Fiesta parade is caught in this photograph as the decorated fishing boat *Sea Scout* passes by with a load of jubilant riders. This event was marked by the blessing of the fleet and is commemorated at Festa Di San Pietro Day. This postcard, mailed July 19 to B. Warren from A-1 Photo Service, reads as follows: "Dear Customer: Your photofinishing work is finished."

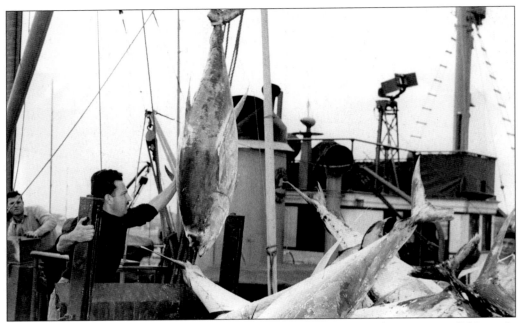

UNLOADING FROZEN TUNA. This *c.* 1950s view shows frozen tuna from a recent fishing trip being unloaded to be processed at one of the many canneries at Fish Harbor on Terminal Island. (Photograph by Crawford.)

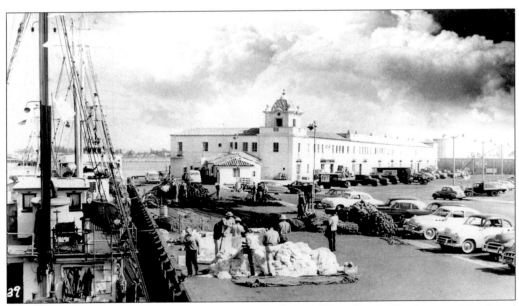

NEW FISHERMAN'S WHARF AND MARKET. Built in 1951 at Berth 80, the new Municipal Wholesale Fish Market at the foot of Twenty-second Street is still in operation today.

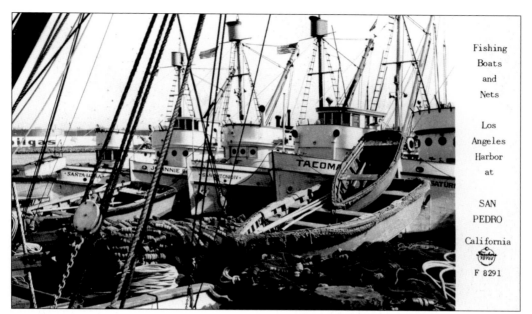

Fishing
Boats
and
Nets

Los
Angeles
Harbor
at

SAN
PEDRO

California

F 8291

FISHING BOATS AND NETS, LOS ANGELES HARBOR. This 1950s postcard documents a common sight in Fish Harbor at the height of the fishing industry, when the boats were "in." Sometimes they were nestled five deep against the dock while waiting for the next run. Some of the boats pictured here are *Santa Lucia, Johnny Boy, San Antonio IV, Tacoma,* and unidentified. (Courtesy of Frasher Fotos.)

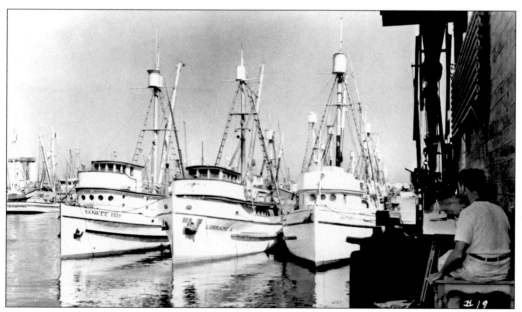

FISHING BOATS AND ARTIST. This picturesque scene shows three purse seiners docked in Fish Slip (formerly Southern Pacific Slip). From left to right are *Yankee Boy, Lorraine A,* and *Sea River.* This postcard was mailed May 22, 1953, from Wilmington to Racine, Wisconsin.

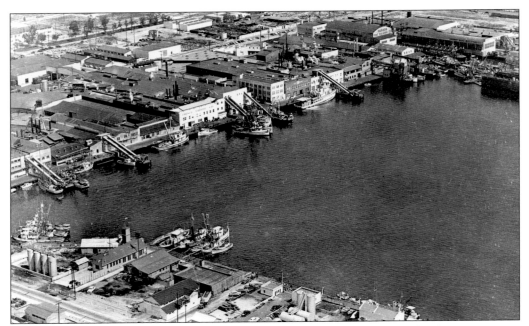

FISH HARBOR. This is a *c.* 1950s aerial view of Fish Harbor on Terminal Island. You can see a few commercial fishing boats docked at the canneries that line the water's edge.

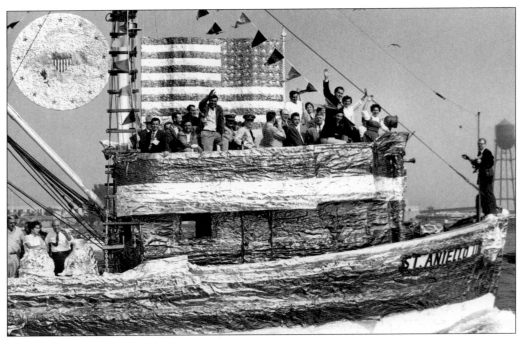

ST. ANIELLO. This *c.* 1960 view shows the St. Aniello, decorated from stem to stern with aluminum foil. Even the round presidential seal and the American flag are made out of aluminum foil. In front of the flag, with his hand raised in the air, is then former vice president of the United States Richard M. Nixon with his wife, Pat.

Five

SAILING, STEAMSHIPS, AND MILITARY

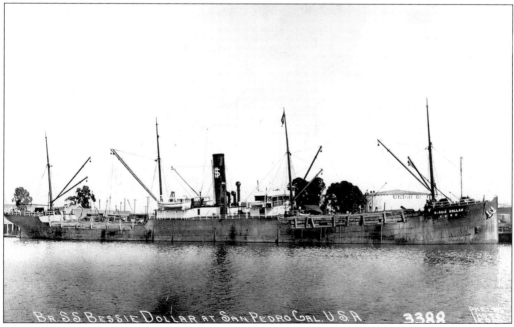

SS BESSIE DOLLAR. This *c.* 1905 postcard of the SS *Bessie Dollar* shows a dollar sign on her smokestack and her decks loaded with lumber as she is docked in front of Union Oil tanks (Berths 150-151) in San Pedro. (Courtesy of Phelps Photo Pedro.)

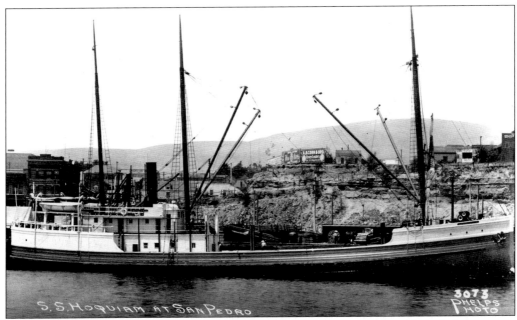

SS HOQUIAM. The SS *Hoquiam* is tied up at the docks near First Street, *c.* 1906. A few men on the deck of the ship are unloading lumber, which will be hauled away by the Southern Pacific train cars next to the ship. (Phelps Photo Pedro.)

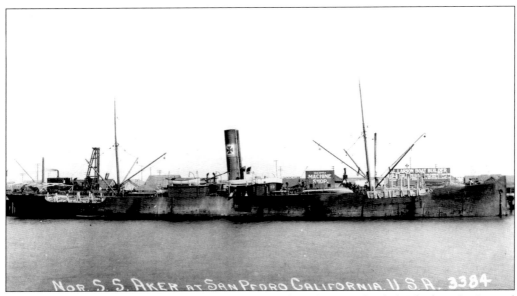

SS AKER. Lumber aboard the Norwegian ship SS *Aker* is being unloaded. The boat is pictured docked *c.* 1905 in front of the Al Larson's Boat Builder facility, which opened for business in 1902.

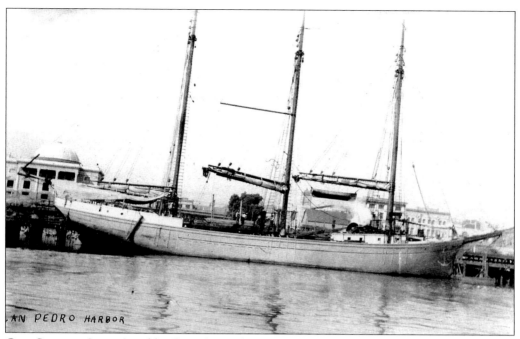

OLD SAILING SHIP. An old sailing ship is docked in the Main Channel about Seventh Street. The domed building in the background is the newly completed San Pedro City Hall that was finished in 1908. The other buildings pictured are along Front Street.

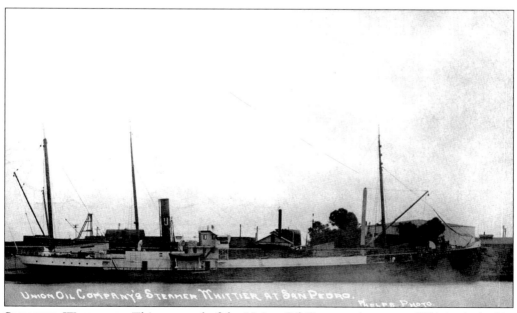

STEAMER WHITTIER. This postcard of the Union Oil Company's steamer *Whittier* docked in San Pedro was mailed September 10, 1907, with no message. (Courtesy of Phelps Photo.)

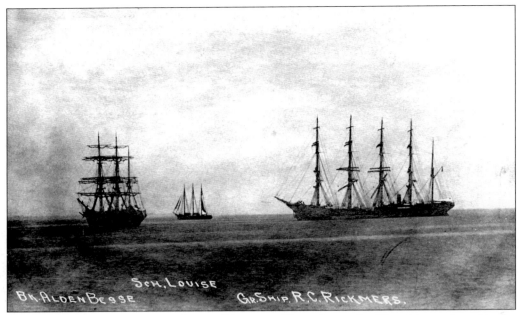

SAILING SHIPS ANCHORED IN OUTER HARBOR. These three tall sailing ships anchored in the outer harbor of San Pedro Bay are, from left to right, barkentine *Alden Beese*, schooner *Louise*, and German *R.C. Rickmers.* This card is from September 11, 1907.

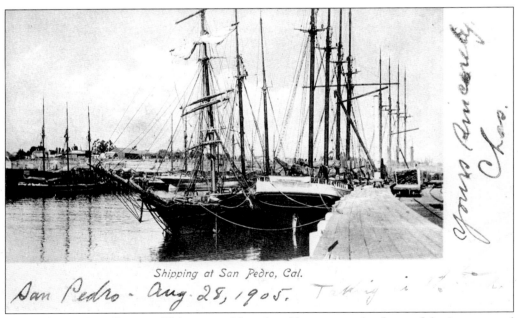

SHIPPING AT SAN PEDRO. This postcard has the oldest postmark of any of the images used in this book. Mailed August 28, 1905, it contained this message: "Taking in the town Yours Sincerely Chas." This is the old narrow, and the only channel in the harbor with sailing ships delivering lumber. (Courtesy of M. Rider, Los Angeles.)

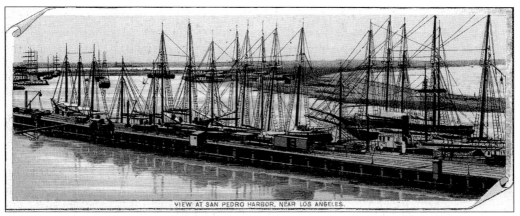

VIEW AT SAN PEDRO HARBOR NEAR LOS ANGELES.

VIEW AT SAN PEDRO HARBOR NEAR LOS ANGELES. This is a turn-of-the-century view of the harbor, with several tall sailing ships docked along the main channel. East San Pedro (Rattlesnake Island, later named Terminal Island) is across the channel.

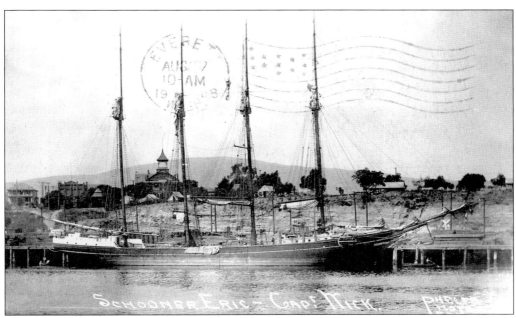

SCHOONER *ERIC* AND CAPTAIN WICK. This is a very early view from the East San Pedro side of the channel, looking west. The tall cupola of Hotel Clarence is visible on the bluff above the ship. Mailed August 8, 1908, to Everett Washington, the message reads as follows: "Was Robert Louis Stevenson's ship bought by Captain Wick which sank on second trip up north. Martha went on it with him to Honolulu. One child of hers born on here." (Courtesy of Phelps Photo Pedro.)

97

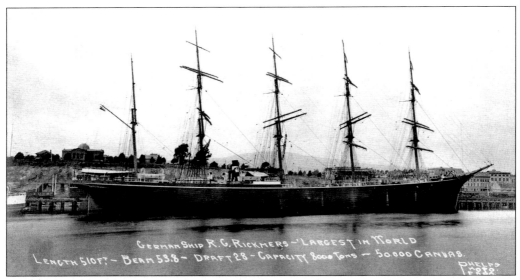

GERMAN *R. G. RICKMERS.* With a length 510 feet, a beam of 538, a draft 78, and a capacity of 8,000 tons, and with "50,000 canvas," it overwhelms the Carnegie Library, which peeks out over the stern of the ship at the top of Beacon Street. This postcard is dated September 11, 1907. (Courtesy of Phelps Photo Pedro.)

SMALL SAILING VESSELS. This *c.* 1905 postcard shows several small sailboats anchored in San Pedro Bay, with Deadman's Island in the background. The message reads, "At San Pedro in the bay small private craft Deadman's Island in the background, several years ago a number of American sailors were buried there."

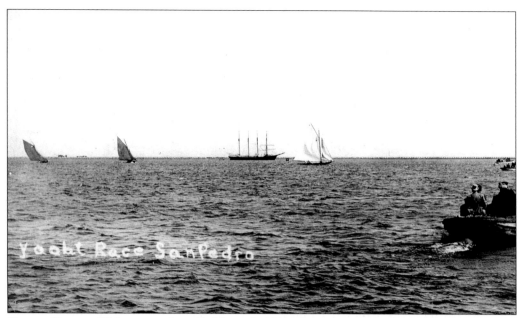

YACHT RACES. This postcard, mailed June 8, 1911, shows spectators in small boats watching the yacht race in the outer harbor behind the Government Breakwater, which was still under construction at the time.

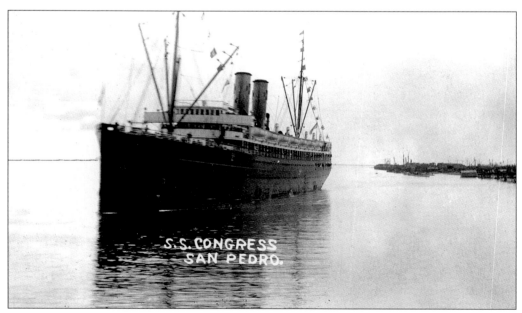

SS CONGRESS, C. 1915. Pictured here entering San Pedro Bay, the SS *Congress* passenger liner was owned by the Pacific Steamship Company.

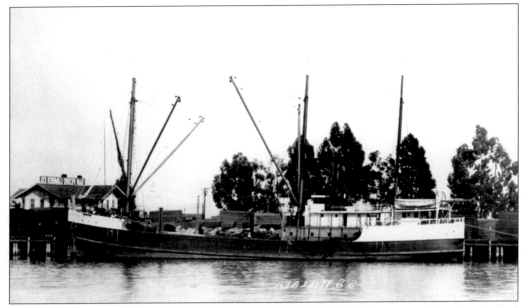

SS WILLAPA. This *c.* 1913 postcard shows the SS *Willapa*, her deck loaded with lumber, docked at the San Pedro Lumber Company. A close look at the lettering on the sign of the lumber company and the written name of the ship reveals that they are backwards. The negative used for this photo card was printed from the wrong side.

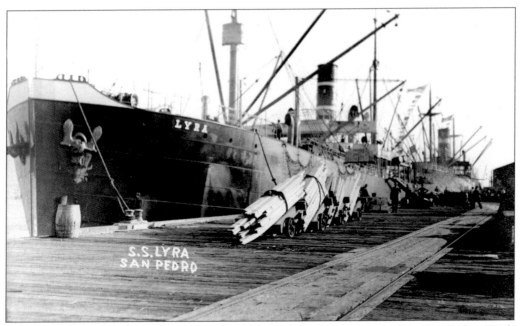

SS LYRA. This 1910s view shows the cargo ship SS *Lyra* tied up at a dock in San Pedro. With stacks of lumber on small wagons lined up near the bow of the ship, longshoremen are loading other cargo onto the ship.

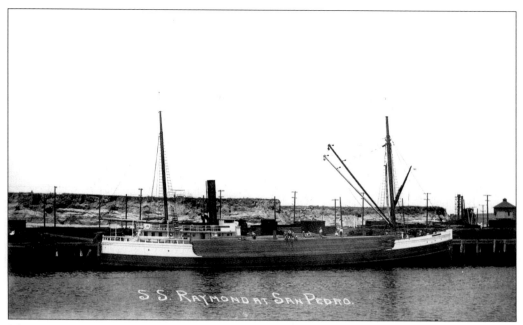

SS RAYMOND. Crews of men on the deck of the SS *Raymond* are unloading its lumber cargo. This postcard was mailed June 7, 1910, with the following message: "We are all well and are having a good time here is Raymond we was fishing this morning and Begina caught one fish."

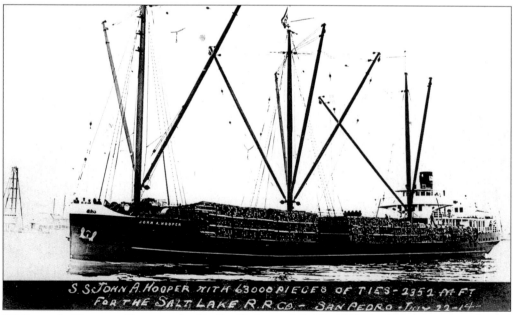

SS JOHN A. HOOPER. Photographed in San Pedro on July 22, 1914, the SS *John Hooper* is loaded with 6,300 pieces of much-needed railroad ties or the developing harbor to move cargo in and out of the area—2,352 million feet for the Salt Lake Railroad Company.

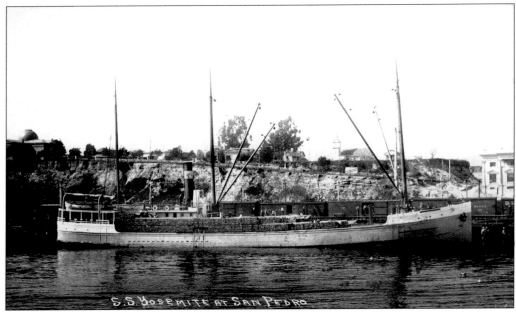

SS YOSEMITE. The SS *Yosemite* is tied up at the docks at about Eighth Street. The Carnegie Library can be seen on the hill to the left, and the San Pedro City Hall building is to the right. This postcard was mailed February 17, 1915, and the message says "This is a lumber carrier that sails between here and Portland unloading railroad ties."

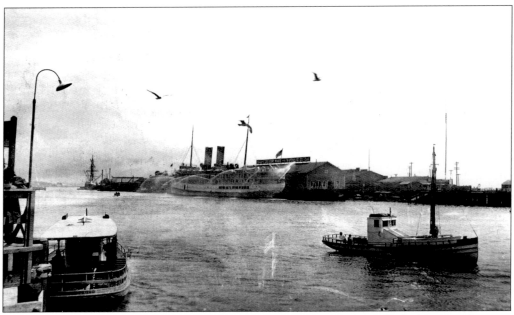

SS HARVARD, C. 1915. Streams of water pour out from the SS *Harvard*, docked next to Crescent Wharf and Warehouse Company Coal in East San Pedro. The empty water taxi *Real* can be seen near its dock at Fifth Street.

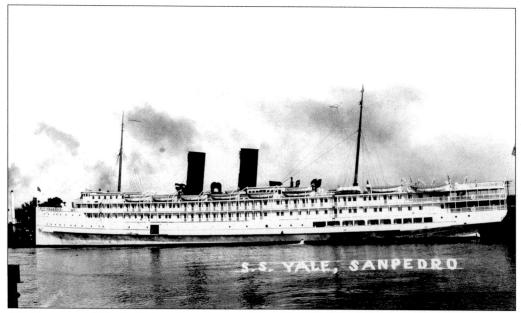

SS *YALE, C.* **1915.** Built in 1906, the SS *Yale* was chartered in 1908 by the Pacific Steam Navigation Company to operate between Los Angeles and San Francisco. From 1920 through the 1930s, it operated under the Los Angeles Steam Ship Company. Matson line took over LASS Company in 1930.

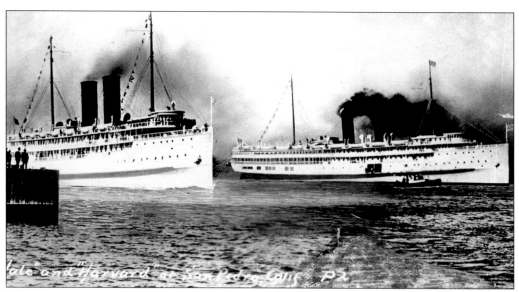

YALE **AND** *HARVARD.* This photo card from 1920s shows the *Yale* and the *Harvard* as they traveled between San Francisco and Los Angeles. They were the fastest passengers liners on the Pacific Coast, for the Pacific Navigation Company's ship operation.

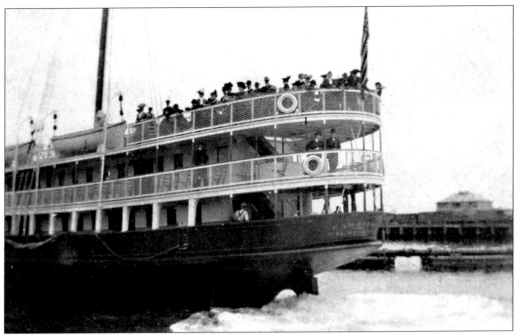

SS CABRILLO. This *c.* 1910 postcard of the SS *Cabrillo* shows it leaving San Pedro and headed to Catalina. The ship was built in 1902 for the Banning family to carry passengers to Avalon.

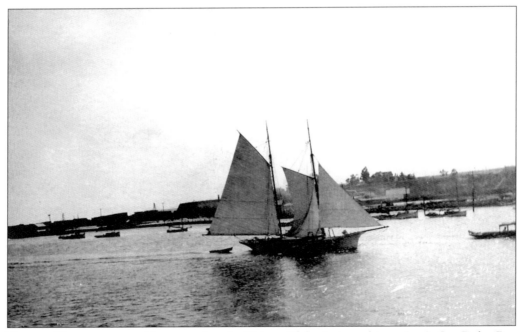

YACHT. The message on this postcard reads, "A beautiful private yacht coming in San Pedro Bay He begins taking in sail just as I snapped." This 1906 postcard never got addressed or mailed.

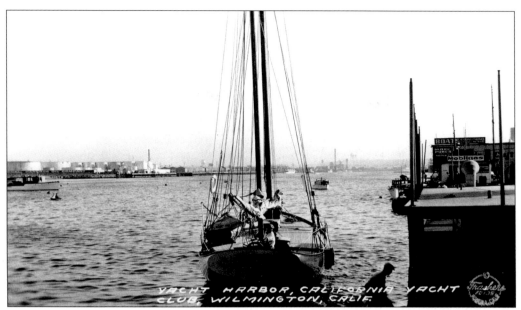

YACHT HARBOR AND CLUB, WILMINGTON. A *c.* 1925 view shows the yacht harbor in Wilmington, with one yacht leaving the dock and heading out into the main channel of San Pedro Bay. Across the channel are the storage tanks of Hancock Oil Company. (Courtesy of Frasher Fotos.)

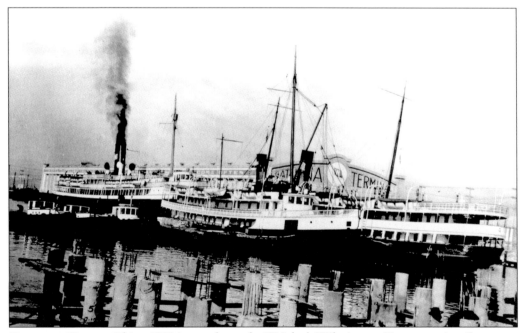

CATALINA DOCKS. This *c.* 1923 image shows the Wrigley's Wilmington Transportation Company, Catalina Terminal in Wilmington. The SS *Hermosa* and SS *Cabrillo*, along with other company ships, tied up at the Catalina docks.

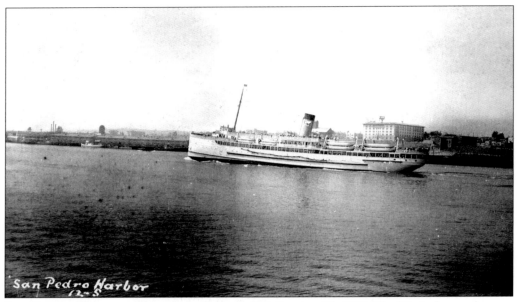

SAN PEDRO HARBOR. This postcard was mailed October 17, 1927. The SS *Avalon* can be seen leaving San Pedro and sailing down the main channel at just about Seventh Street. The former YMCA building is behind the ship.

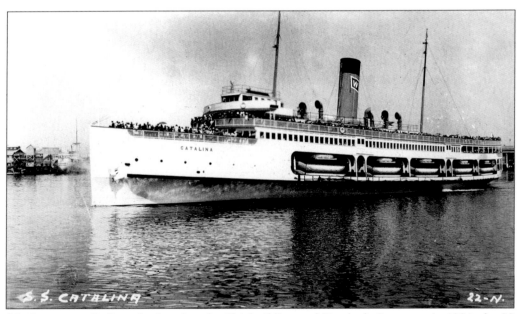

SS *CATALINA*. Built at the Los Angeles Shipbuilding and Drydock Company in 1924, the SS *Catalina* was the link between Catalina Island and the mainland. The "Great White Steamer," as it was more commonly known, traveled between San Pedro Bay and Catalina for 51 years.

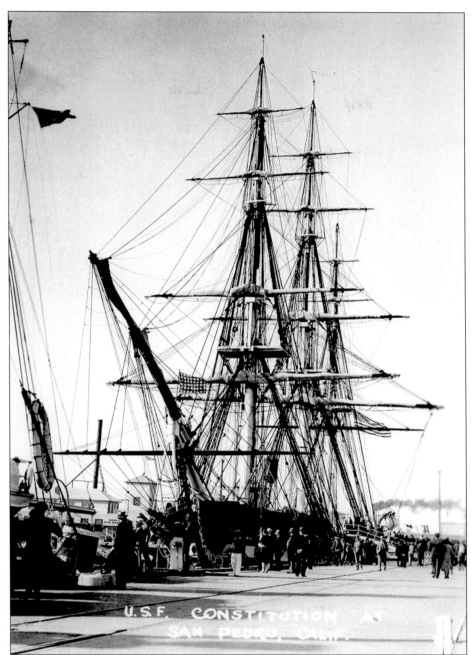

USS CONSTITUTION. Crowds at the San Pedro Navy Landing wait to get a glimpse of the USS *Constitution* between October 19 and November 2, 1933. The *Constitution* was called "Old Ironsides" because bullets could not penetrate her tough oak sides. This ship was one of the first of the original six frigates that made up the U.S. Navy. The 44-gun frigate carried a crew of more than 450 and was built at the Edmonds Hartt Shipyard, Boston, Massachusetts, in 1797. Restored in 1925, the USS *Constitution* in now the oldest commissioned vessel in the U.S. Navy. It presently serves as a museum ship at the Charleston Navy Yard in Boston.

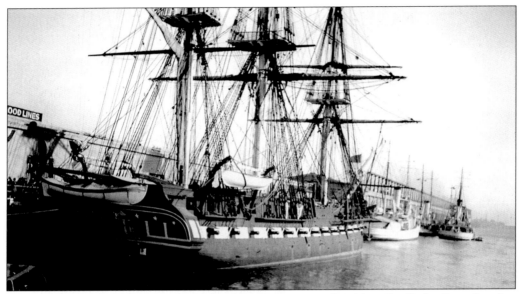

"OLD IRONSIDES." A tugboat assists the USS *Constitution* on its visit to San Pedro from October 19 to November 2, 1933. Under Comdr. Louis J. Gulliver, "Old Ironsides" traveled 22,000 miles, visited 90 ports, and welcomed more than 4.6 million visitors—with two million in California alone.

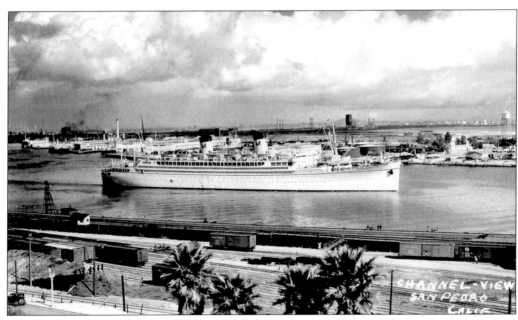

LURLINE **IN MAIN CHANNEL.** This view of the passenger ship shows the *Lurline* steaming out of the main channel while a few people stand next to the rail lines on the waters edge. The Bethlehem Shipyard in Quincy, Massachusetts, built this luxury liner in 1932 for the Matson Navigation Company. It started sailing the Pacific route from San Francisco to Los Angeles and the Honolulu route in 1933.

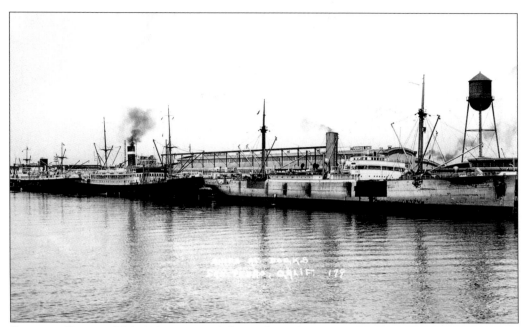

SHIPS AT DOCKS. This 1920s postcard shows three ships tied up at the docks in San Pedro, in front of the Furness Line building. The merchant ship on the right is the *Knoxville City*, but the names of the other two passenger ships are unknown. (Courtesy of J. Bowers Photo Company, Long Beach.)

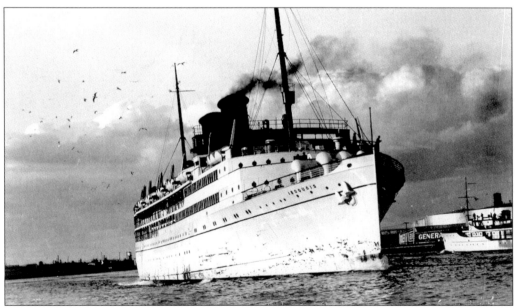

SS IROQUOIS. A *c.* 1931 postcard of the passenger ship SS *Iroquois* (built in 1927) sailed for about one year for the Los Angeles Steamship Company. It was the replacement ship for the SS *Harvard* and *Calawall*.

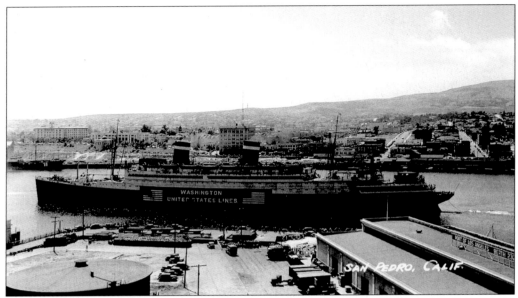

WASHINGTON, UNITED STATES LINE. In this *c.* 1940 view, the passenger ship *Washington* can be seen moving southward along the main channel in San Pedro at about Seventh Street, where the city municipal building is visible. Until the outbreak of war in Europe, this ship sailed from New York to Europe. Starting in July 1940, this ship sailed from New York to the West Coast. The U.S. Navy commandeered the ship in 1941 to use for troop transport until the end of the war.

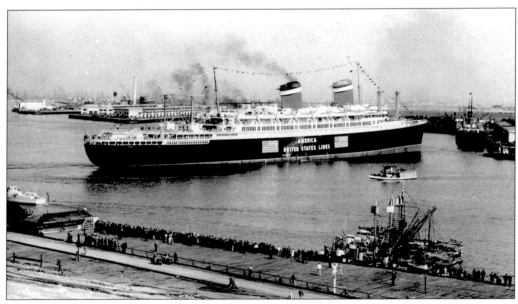

AMERICA, UNITED STATES LINE. This 1940 view of the passenger ship *America* shows a large audience standing on the dock and watching the ship maneuvere into position on the main channel (about Fifth Street) of San Pedro Bay. Launched August 31, 1939, and delivered July 2, 1940, *America* was intended for Atlantic service, but due to war in Europe, it was used for cruising from New York to the West Indies and onto the West Coast.

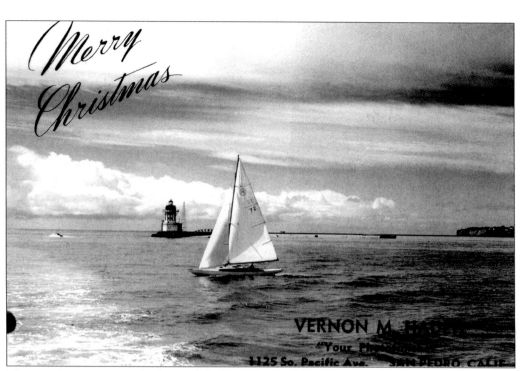

MERRY CHRISTMAS. This beautiful *c.* 1950s postcard, showing a sailboat passing in front of Angel's Gate Lighthouse, is a perfect advertisement for Vernon M. Haden, "Your photo finisher" at 1125 South Pacific Avenue.

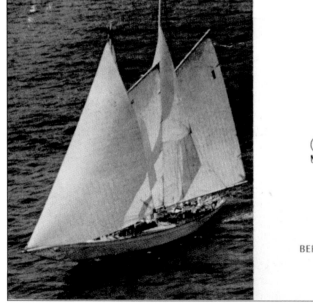

The Schooner

SALEE

★ ★ ★

BERTH 76, PORTS OF CALL VILLAGE
SAN PEDRO, CALIF.

SCHOONER *SALEE*. In the 1960s, this was the largest sailing vessel on the West Coast certified by the U.S. Coast Guard to carry passengers. The 90-foot-long schooner operated out of Berth 76 in Ports o' Call Village.

OLD STEAMSHIP DOCKED IN SAN PEDRO. Around 1899, an old steamship is tied up at a dock in San Pedro Bay next to a few other tall sailing ships.

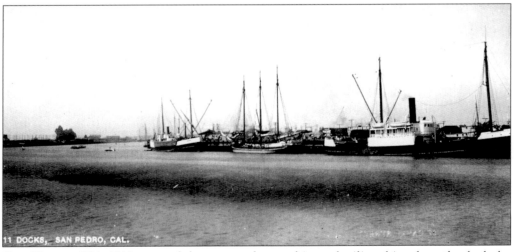

OLD DOCKS. This 1911 postcard shows several steamships and sailing ships along the docks by Al Larson's Boat Builder.

Six

MILITARY

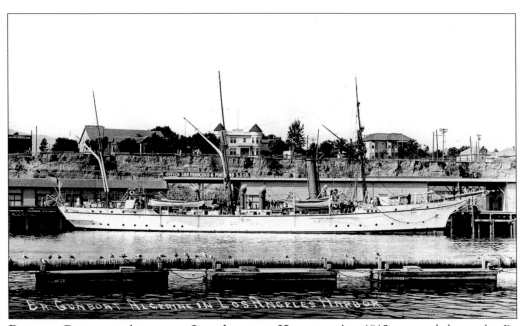

BRITISH GUNBOAT *ALGERINE*, LOS ANGELES HARBOR. A *c.* 1915 postcard shows the *Br. Gunboat Algerine* tied up at the docks of the "Office of San Francisco & Portland S.S. Co." with many older homes on the bluff overlooking the channel.

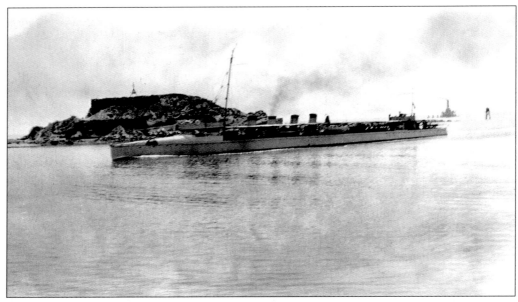

NAVY SHIP PASSING DEADMAN'S ISLAND. This 1900s postcard shows a Navy ship steaming past Deadman's Island. This picture was taken before there were any signs of construction of the Government Breakwater on the horizon.

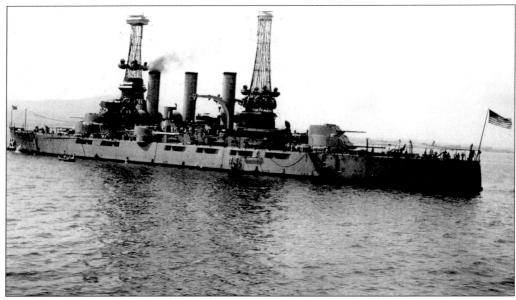

BATTLESHIP USS *VERMONT* (BB20). The battleship USS *Vermont*, pictured in San Pedro Harbor August 20, 1919, was on a brief stop before sailing north. This battleship was decommissioned less than a year later, on June 30, 1920.

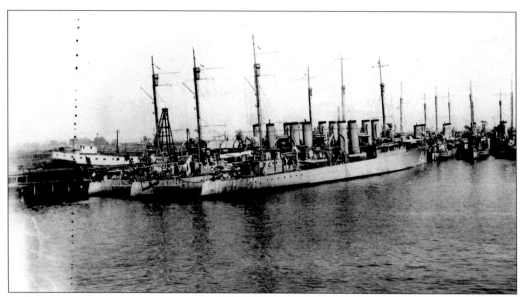

U.S. Navy Destroyers Docked at San Pedro. A handwritten message on the front of this postcard reads as follows: "A nest of Uncle Sam's Destroyers docked in the main channel of San Pedro Harbor August 20, 1919."

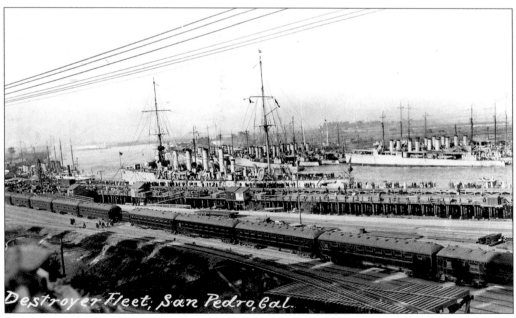

Destroyer Fleet This postcard was mailed October 26, 1920, with this message: "Am leaving for Honolulu tomorrow, be good will write when I get there." Destroyers are on both sides of the main channel near Seventh and Ninth Streets. In August 1919, President Wilson had transferred 200 warships to the Pacific to be ported in San Pedro Bay.

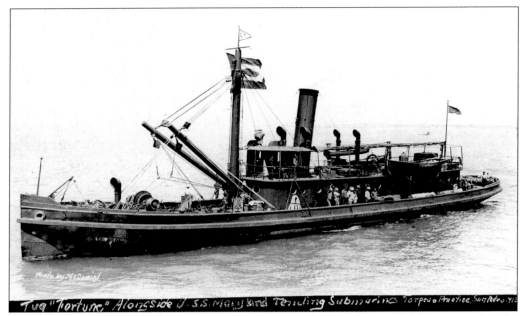

USS FORTUNE SUBMARINE TENDER. The message written on bottom of this postcard reads, "Tug *Fortune* alongside USS *Maryland* tending submarines Torpedo practice San Pedro 1912." (Photograph by McDaniel.)

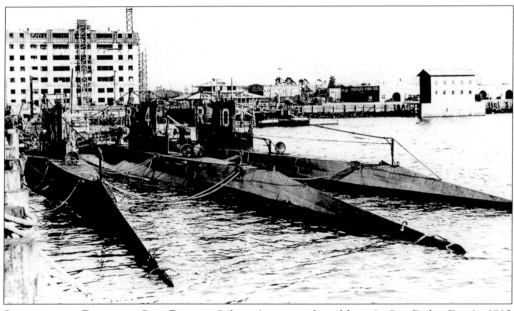

SUBMARINES BASED IN SAN PEDRO. Submarines were based here in San Pedro Bay in 1913 before the battleships arrived in August 1919. Construction of Los Angeles Harbor Warehouse No. 1, visible in the background, was started in 1915.

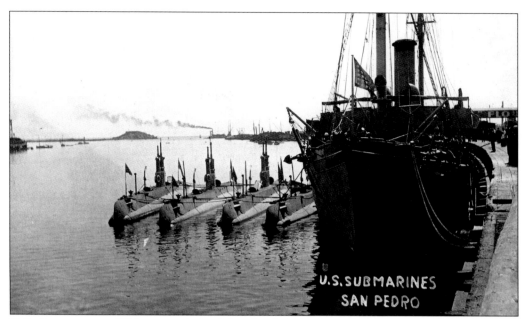

U.S. Submarines. This postcard, dated October 7, 1914, shows four submarines and their tender docked near Sixth street. By 1923, the submarine base in San Pedro was closed down.

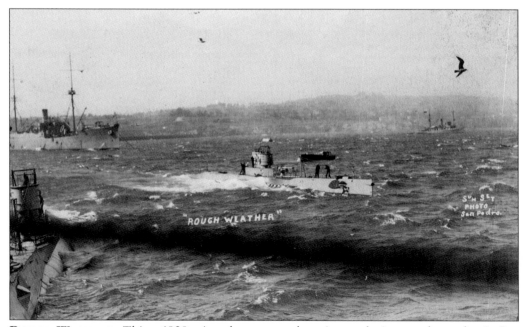

Rough Weather. This *c.* 1920s view shows two submarines enduring rough weather in San Pedro Bay, with Palos Verdes Hill in the background. (Photograph by Sunset, San Pedro.)

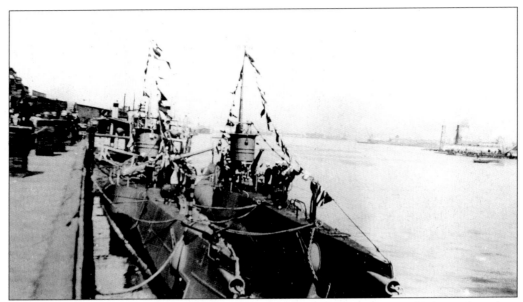

PAIR OF EARLY SUBMARINES. A *c.* 1920s view shows two flag-decorated Navy submarines docked in the main channel of San Pedro Bay.

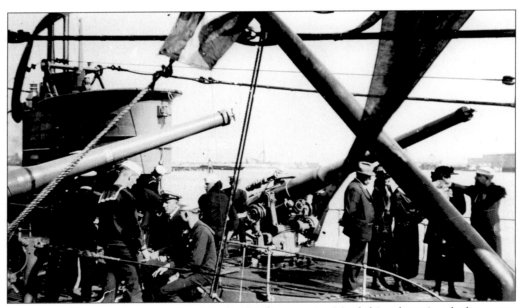

CIVILIANS VISITING NAVY SUBMARINES. Civilian guests visited this submarine deck to get a close-up view of its artillery.

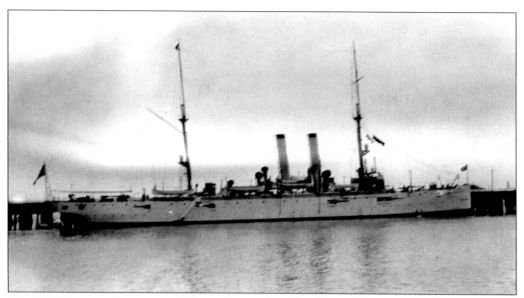

NAVY SHIP DOCKED IN SAN PEDRO. An unidentified Navy ship is shown tied up at a dock in San Pedro Bay *c.* 1920.

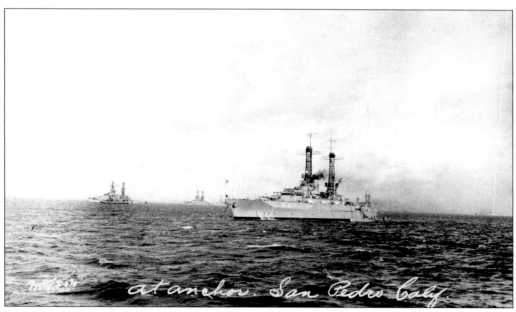

BATTLESHIP USS *NEW MEXICO* (BB-40). The battleship USS *New Mexico,* upon its arrival at San Pedro in August 1919, was Adm. Hugh Rodman's Pacific fleet flagship. It was home ported here from 1919 until 1940, when it went to Pearl Harbor. This battleship was commissioned in May 1918 and decommissioned in July 1946. (Courtesy of M. L. Foto.)

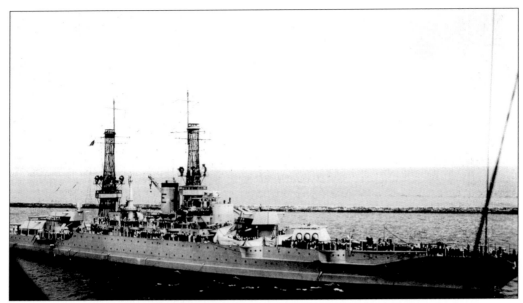

BATTLESHIP USS *MISSISSIPPI* (BB-41). Aboard the battleship USS *Mississippi*, during gunnery practice on June 12, 1924, off San Pedro, 48 men died from an explosion in the No. 2 main battery gun turret. This battleship was home ported here from 1919 till 1940, when it went to Pearl Harbor. This battleship was commissioned in December 1917 and decommissioned in September 1956.

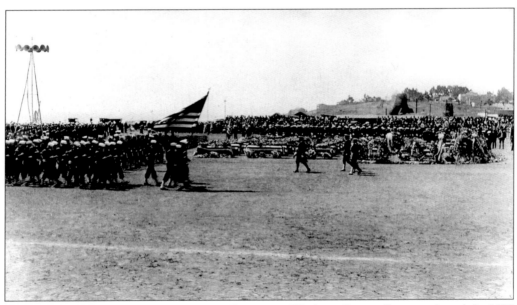

SAILORS PARADE FORMATION DURING FUNERAL. Victims of a gun flare-up aboard the USS *Mississippi* were honored on June 17, 1924.

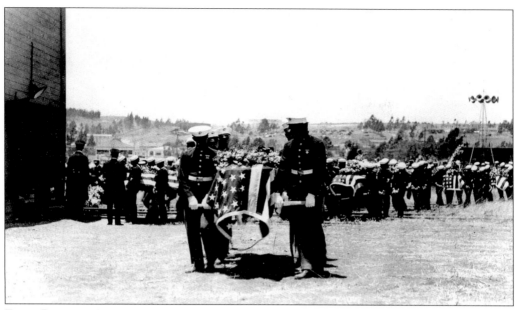

FLAG-DRAPED COFFINS. On June 14, 1924, sailors carry the flag-draped coffins of the 48 men that perished during gunnery practice on the USS *Mississippi.*

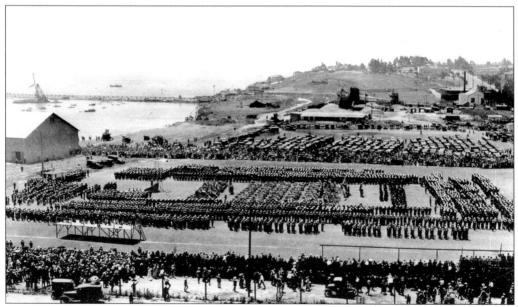

TRONA FIELD. The funeral service for the sailors who died on the USS *Mississippi* was held at San Pedro's Trona Field. A large number of civilians were also in attendance. They are pictured around the Navy personnel in the center of field.

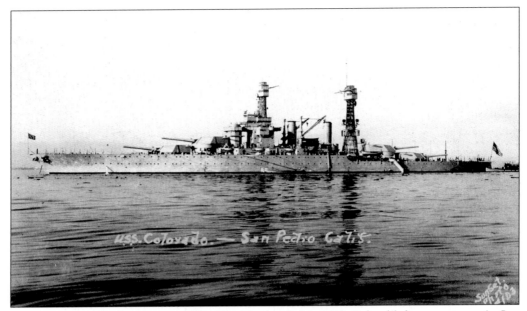

BATTLESHIP USS COLORADO (BB-45). The battleship USS *Colorado*'s homeport was in San Pedro Bay between 1924 and 1940. This battleship was commissioned in March 1923 and decommissioned in March 1959. (Photograph by Sunset, San Pedro.)

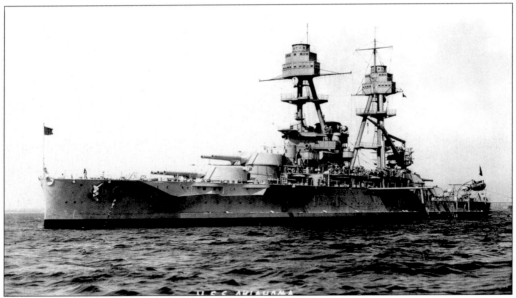

BATTLESHIP USS OKLAHOMA (BB-37). The USS *Oklahoma* had its homeport in San Pedro Bay from 1921 to 1927 and 1930 to 1940. One of the sons of the Point Fermin lighthouse keepers, Joseph Semon Austin, served on this battleship for several years before the outbreak of World War II. It was commissioned in May 1916 and decommissioned in September 1944.

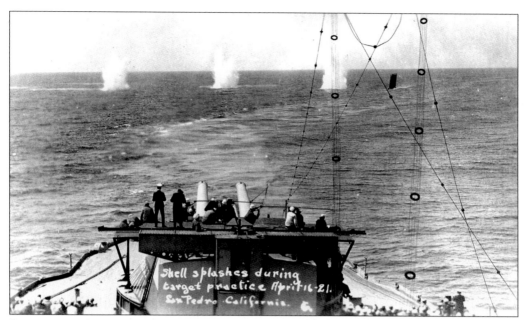

BATTLESHIP GUNNERY PRACTICE. Shells splash during target practice on April 16, 1921. Being towed behind a battleship is the target screen being used for this exercise.

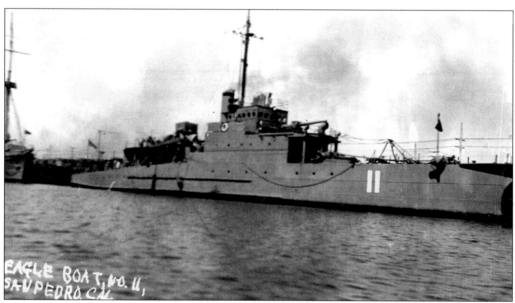

USS EAGLE II (PE-20). This is a *c.* 1920s view of the USS *Eagle II*, built by Ford Motor Company for World War I but not finished until after the war had ended. It was originally designed as an anti-submarine vessel to combat the U-boat menace. The term Eagle Scout boat came from a 1917 editorial in the *Washington Post* that called for an eagle to scout the seas and pounce upon and destroy every German submarine.

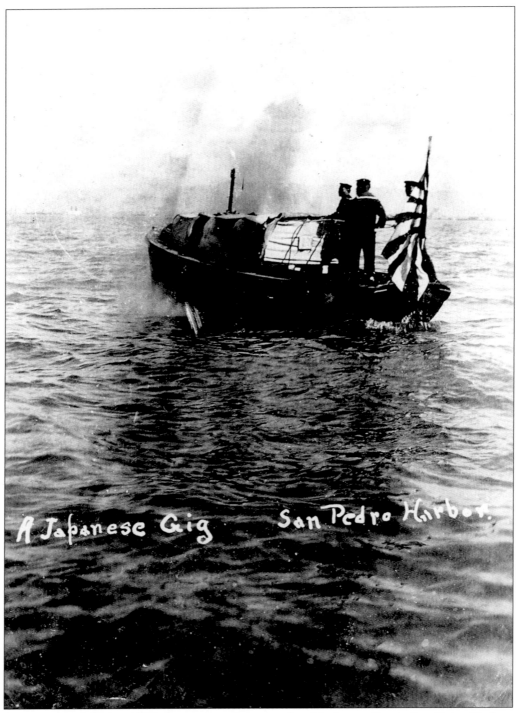

A Japanese Gig San Pedro Harbor

JAPANESE GIG. This *c.* 1925 view shows a Japanese gig with three sailors in San Pedro Harbor. Despite growing tensions between the United States and Japan, regular visits by Japanese training ships continued through the 1930s.

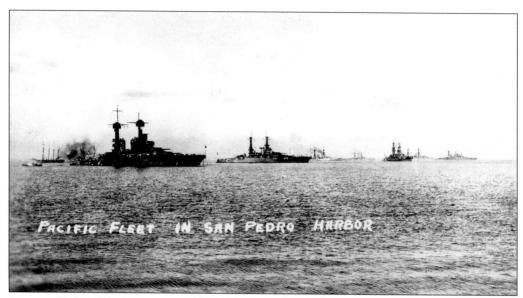

PACIFIC FLEET HOMEPORTED. This 1920 view shows most of the battleships of the Pacific fleet anchored in San Pedro Bay. The Pacific fleet was home ported here from August 1919 until 1940. Most of the ships stationed here were then sent to Pearl Harbor just before the start of World War II.

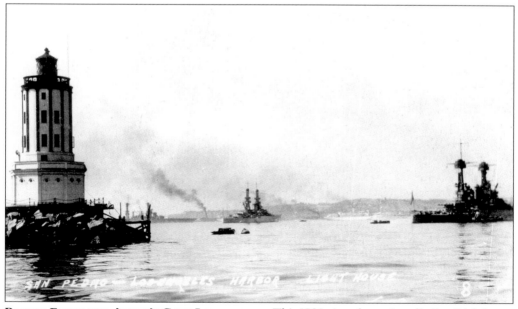

PACIFIC FLEET AND ANGEL'S GATE LIGHTHOUSE. This 1920 view shows Angel's Gate Lighthouse on the end of the breakwater. Several battleships of the Pacific fleet are safely anchored in the outer harbor.

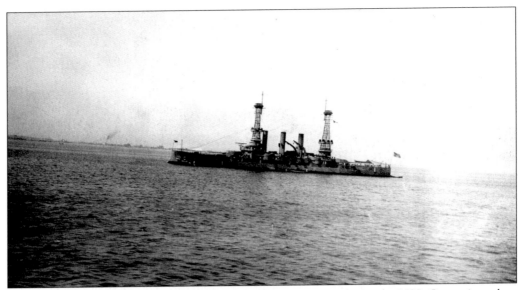

BATTLESHIP USS CONNECTICUT (BB-18). This 1920 view shows the USS *Connecticut* when it was flagship of the Pacific Train. This battleship was commissioned in September 1906 and decommissioned in March 1923.

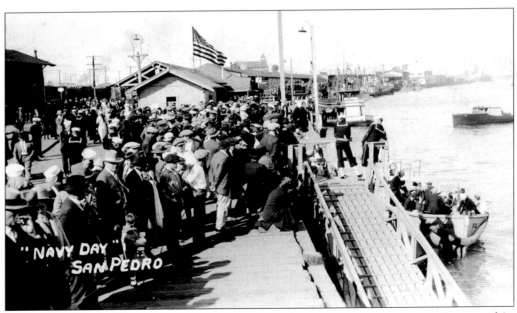

NAVY DAY. The Navy Landing at Fifth Street was located adjacent to Beacon Street and its infamous bars. The Navy later moved the landing to Twenty-second Street.

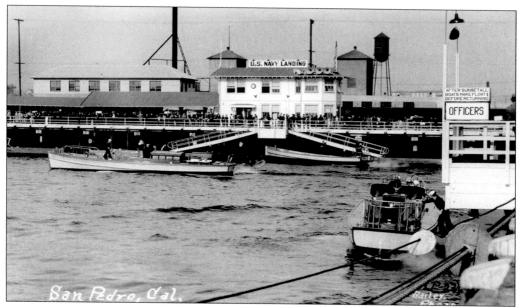

BUSY DAY AT NAVY LANDING. This 1933 photograph illustrates a busy day at the newly completed Navy Landing at Twenty-second Street. The dock is full of civilians and sailors. (Photograph by Bailey.)

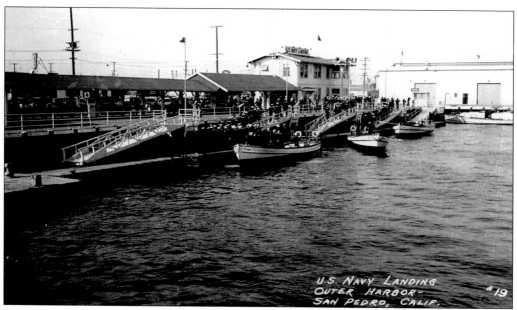

U.S. NAVY LANDING, OUTER HARBOR. This is a 1933 view of the Navy landing built at 22nd Street. The Pacific Electric Red Car line extended to this point so that—in theory—sailors would bypass the temptations from the notorious bars on Beacon Street near the Fifth Street landing.

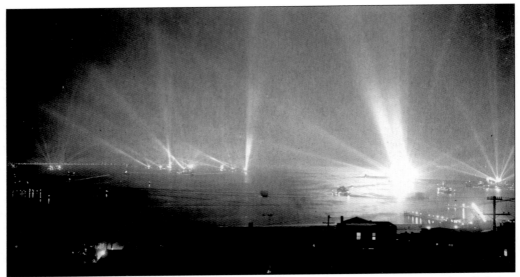

BATTLE FLEET ILLUMINATING NAVY DAY. This 1920s postcard shows the Navy ships lighting up the night sky with their searchlights.

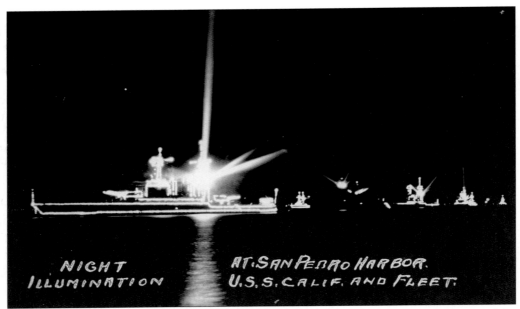

NIGHT ILLUMINATION IN SAN PEDRO BAY. The battleship USS *California* and the rest of the fleet illuminate the outer harbor of San Pedro Bay. The USS *California* was the flagship for the Pacific fleet for 20 years, from 1921 till 1941. It was commissioned in August 1921 and decommissioned in February 1947.